IMAGES
of America

SHREWSBURY

To my sons, Richard and Nicholas—always follow your dreams.

IMAGES
of America

SHREWSBURY

Michael Perna Jr.

ARCADIA

Published by Arcadia Publishing,
an imprint of Tempus Publishing, Inc.
2A Cumberland Street
Charleston, SC 29401

Printed in Great Britain.

Library of Congress Catalog Card Number: 2001086465

For all general information contact Arcadia Publishing at:
Telephone 843-853-2070
Fax 843-853-0044
E-Mail sales@arcadiapublishing.com

For customer service and orders:
Toll-Free 1-888-313-2665

Visit us on the internet at http://www.arcadiapublishing.com

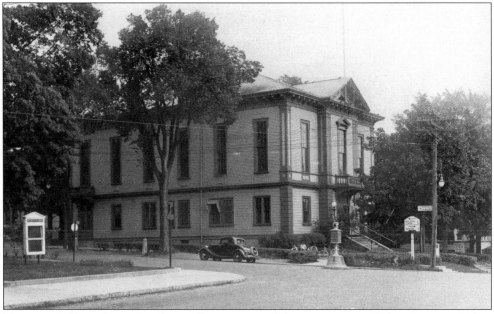

The town hall was located at the northeast corner of the intersection of Main Street and what is now Route 140. When it was built, $14,999.37 was used out of a budget of $15,000, leaving a balance of 63¢. Throughout its many years of service, the building was put to good use. In addition to housing the town's offices, it was also used for activities such as meetings, balls, dinners, and stage shows. It was only when the town's need for office space grew that a new municipal building was constructed. The old town hall was torn down in 1967, despite some valiant efforts to keep it standing.

CONTENTS

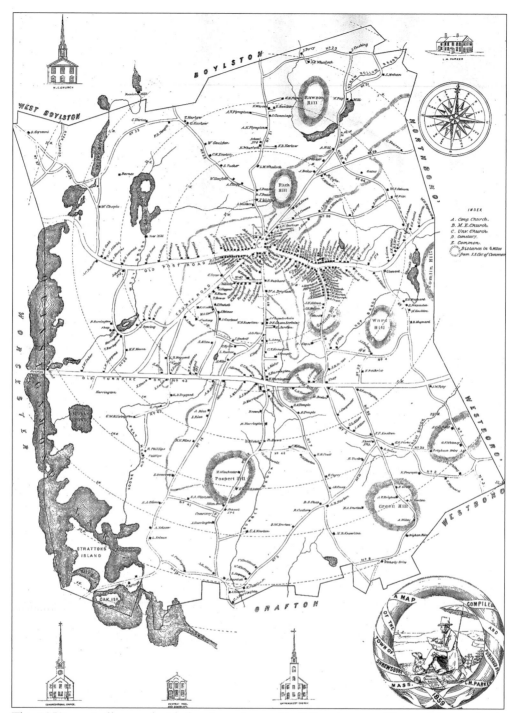

This 1859 map is illustrated with drawings of several buildings in town. The most interesting is the Universalist church, which stood on what was then known as the South Common. The church was torn down sometime in the late 1800s. No other view of the building has surfaced.

INTRODUCTION

The town of Shrewsbury, Massachusetts, was formed in 1717 from grants of land awarded to a group of 31 people known as the "Proprietors." The grants were awarded with the understanding that at least 40 families and an Orthodox minister be settled in the town within three years. These provisions were met and Shrewsbury was incorporated as a town on December 15, 1727.

The original area of Shrewsbury was much larger and included parts of several surrounding towns. The first settlers built a meetinghouse and arranged for a "burying ground." Although the town was initially reluctant to spend money erecting schools, it eventually did, but not without problems. The town was fined nine pounds in 1769 for not having a grammar school in operation.

Although Shrewsbury was a small farming community, it was not without industrious and inventive citizens. Luther Goddard was the first person to produce watches in quantity in this country. Nymphas Pratt opened what would be the town's largest single business for many years, which was a tannery in the Lower Village. Several noted gunsmiths included Joab Hapgood. Both he and Joel Nurse invented improved plows for farmers. Local farms produced apples, cider, and milk.

Shrewsbury's most famous citizen, Maj. Gen. Artemas Ward, was the first commander in chief of the Revolutionary army. He served in a number of public positions throughout his life. Today, Harvard University preserves his home as a museum.

Unlike many nearby towns, Shrewsbury did not have a railroad or waterway to stimulate commerce. In spite of this, the town had a number of mills operating on local streams. Levi Pease began a stagecoach line that rapidly expanded and earned him the title "Father of the Stages." Later, trolley lines improved the transportation of goods and passengers through the town, replacing the venerable stagecoaches.

In the years following the Civil War, the area around Lake Quinsigamond began to develop. A multitude of social, ethnic, and athletic clubs were built, along with summer hotels and cottages. Other attractions included a horse-racing track in Edgemere and the White City Amusement Park. Steamboats transported sightseers up and down the lake.

As the years passed, Shrewsbury grew more and more quickly. As the town grew, many of the old farms and open spaces were converted into businesses and homes. The Shrewsbury of today is very different from the town that existed even 50 years ago.

Although a number of Shrewsbury's early residents recorded the history of the town, there

has not been a book published on the subject since the late 1800s. One exception, *Remembering Lake Quinsigamond: From Steamboats to White City* (1998), details the exciting attractions that existed around the lake area.

Starting in January 1998, a series of weekly articles on the history of the town were published in the *Shrewsbury Chronicle*. These proved to be extremely popular with the residents of Shrewsbury. This enthusiasm provided the inspiration to produce a photographic history of the town—something that has never been done before. In writing this book, I endeavored to make it into a community project. Many individuals were nice enough to share photographs that represent interesting parts of the town's history, and I would like to commend and thank them. I would also like to recognize the assistance and cooperation of the *Shrewsbury Chronicle*, James Morgan, and the Shrewsbury Historical Society.

The results of this work are now a reality in *Images of America: Shrewsbury*. This book will provide past, current, and future residents a window to the past, a way to view the town of Shrewsbury as it once was.

—Michael Perna Jr.

One

THE CENTER

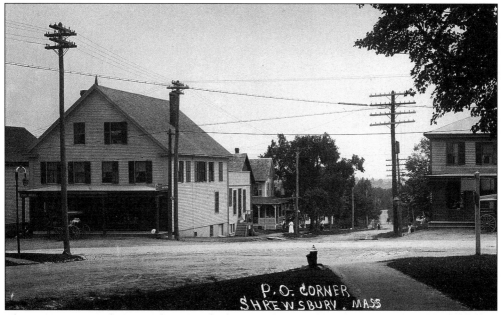

The town center is shown in this view, looking south toward Graftron Street. On the left is S.I. Howe's store, which housed the post office at the time. The carriage on the far right appears to be a delivery wagon for a Northborough baker.

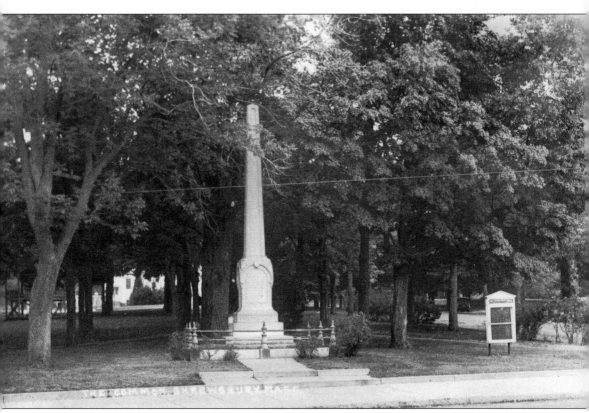

After the Civil War, the town erected a memorial to the 29 Union soldiers from town who made the ultimate sacrifice. One account described this monument: "In 1869, Thomas E. Tateum of Worcester erected upon the 'Common' a marble shaft at an outlay of $4,000, exclusive of foundations. The funds were secured at first through fairs, lectures, etc. The old Shrewsbury Rifle Company sold its tent equipment at auction in 1866 for $68.50 and donated the sum to the fund. By such means, $1,500 was acquired and the town added $2,500." The monument was toppled during a terrible ice storm and landed on the watering trough that once stood in front of it. It was repaired, however, and has stood on the same spot ever since.

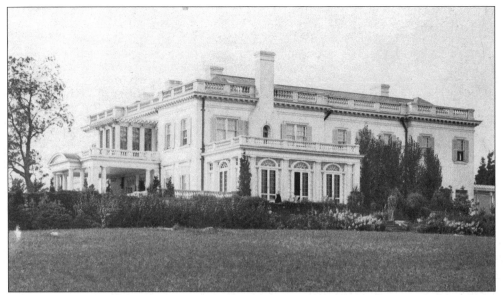

Known as Juniper Hall, this mansion was built by Matthew J. Whittall, who owned a huge carpet mill complex in Worcester. After his death in 1922, Whittall's widow gave the estate to the Masons, who used it as a hospital. His wife dedicated the "Garden of Sweet Remembrance" to her husband's memory. The Masonic Hospital closed in 1975. The town bought the property in 1976 and had the building torn down in 1979. The site of Juniper Hall, located between Route 140 and Prospect Street, is today overgrown with weeds and brush.

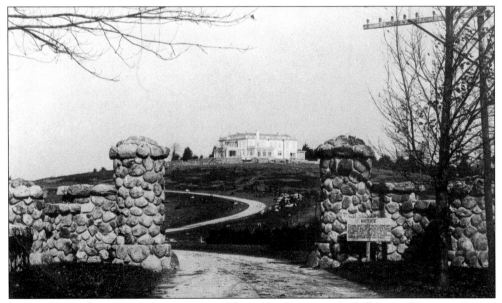

Juniper Hall is shown under construction. The mansion was on the hill west of Prospect Street. This photograph was taken from the driveway and shows the grounds before landscaping was completed. The sign next to the stone pillar reads: "Teams must keep on the driveway. Teamsters must be sure no other teams are coming in opposite direction to avoid turning out. Any cost of repairs for damage to the grounds will be charged owners of teams causing such damage. M.J. Whittall."

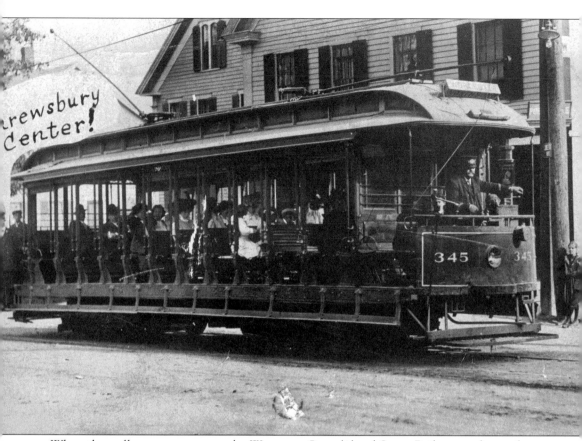

When the trolleys came to town, the Worcester Consolidated Street Railway tracks ran from Lake Quinsigamond, through Shrewsbury Center, and then to Marlborough and points east. Here, car No. 345 of the Worcester Consolidated Street Railway passes through the center of town on the way to Worcester. The Laconia Car Company built this car in 1900. No. 345 was a frequent visitor to Shrewsbury—no less than six different views exist with this same trolley car shown at various places in town.

Compared to modern times, Miss Martha Ducey's Tea Room was a reflection of the slower pace of life in Shrewsbury in the 1920s and 1930s. Located on Maple Avenue at the corner of Wesleyan Street, the tearoom was a popular spot with the ladies of the town. In addition to running the tearoom, Ducey served for many years as the head of the Shrewsbury Welfare Department. The tearoom building survives today as a private residence. Many years ago, it was moved slightly and turned, so it now faces Wesleyan Street.

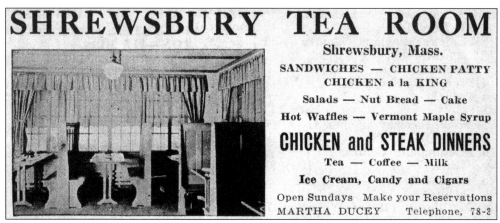

SHREWSBURY TEA ROOM

Shrewsbury, Mass.

SANDWICHES — CHICKEN PATTY
CHICKEN a la KING

Salads — Nut Bread — Cake

Hot Waffles — Vermont Maple Syrup

CHICKEN and STEAK DINNERS

Tea — Coffee — Milk

Ice Cream, Candy and Cigars

Open Sundays Make your Reservations
MARTHA DUCEY Telephone, 78-3

Shown here is an advertisement from the *Automobile Green Book*, the official guide of the American Legal Association. The Shrewsbury Tea Room (also known as Miss Martha Ducey's Tea Room) was a recommended stop on the trip from Worcester to Boston. The guide even included directions on how to get there from the corner of Main and Front Streets in Worcester. As can be seen, the menu featured much more than just tea and pastries. The interior is nicely decorated with curtains and booths.

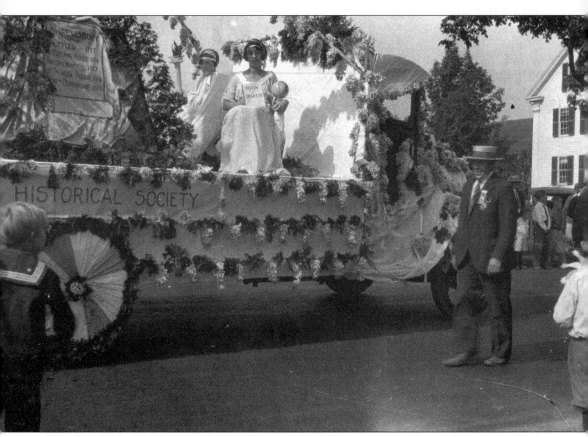

Shrewsbury celebrated its 200th anniversary in September 1927. A gala celebration was held from Thursday, September 8 to Sunday, September 11. The huge parade had a great variety of floats, marching units, bands, and vehicles of all sorts. The float pictured here was entered by the Shrewsbury Historical Society together with the library. A truck loaned for the occasion was draped in greenery, flowers, and crepe paper using a lavender and silver color scheme. Arches rose from each corner and met in the middle. Edson Bigelow, with a white robe and beard, represented Father Time carrying an hourglass and scythe. Helen Holden, carrying a scroll and palm branch, was History. Seen in this view, Josephine Sturtevant carried a flaming torch as Progress, while Cynthia Bigelow held a globe and books as Knowledge. The young ladies wore Greek robes in shades of lavender trimmed with silver. (Courtesy Shrewsbury Historical Society.)

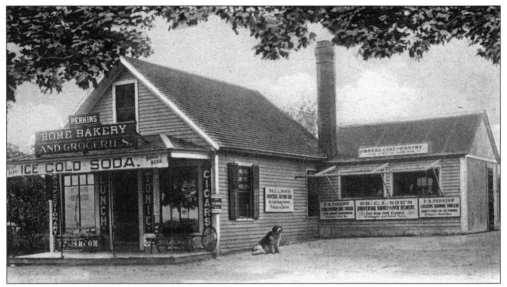

Perkins Home Bakery and Groceries, Shrewsbury's first bakery, opened in June 1897. Among the many items that could be found for sale here were ice-cold soda, birch beer, root beer, Moxie, and cigars. Medicines were also carried, including Dr. C.L. Roe's Universal Kidney and Liver Remedy and F.H. Perkins's own line of patent remedies. The bakery, now long gone, stood near what is today 40 Maple Avenue.

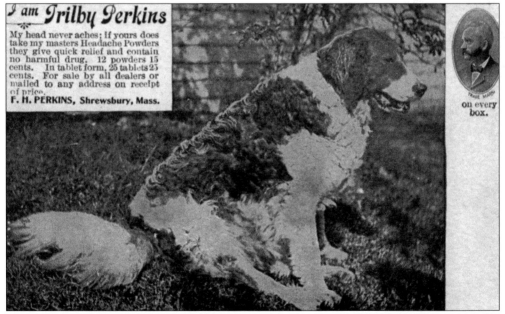

I am **Trilby Perkins**

My head never aches; if yours does take my masters Headache Powders they give quick relief and contain no harmful drug. 12 powders 15 cents. In tablet form, 25 tablets 25 cents. For sale by all dealers or mailed to any address on receipt of price.
F. H. PERKINS, Shrewsbury, Mass.

on every box.

If anyone ever kept track of which dog was the best known in Shrewsbury, it was probably Trilby Perkins. Trilby's master, F.H. Perkins, opened the first bakery in town in 1897. A huge Newfoundland, Trilby was probably named for a stage play of the same name that debuted two years earlier. It might also be he was named after a fedora-type hat featured in the play. Whatever the case, he was well known about town. Here, Trilby is featured as an advertisement on a postcard. One more item of note—around that time, Shrewsbury had a local baseball team by the name of, you guessed it, the Trilbys.

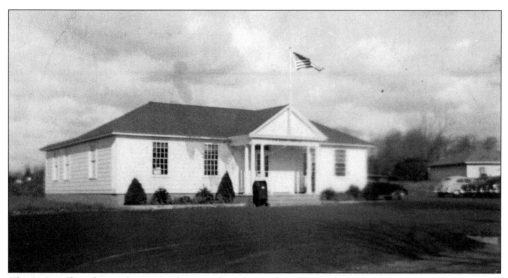

The post office shown here was first used in the early 1950s, when the main post office moved from rented quarters in the town center. Located at 48 Maple Avenue, the post office was needed because of the growth of the town up to that point. This building, however, rapidly became too small. During the busy holiday season, tents were borrowed from the National Guard in order to accommodate the many parcels sent as gifts. The tents were unheated, and postal employees had to work in the cold. The space situation grew worse until the present post office was built in 1975. When the post office moved across the street, the old building was used for office space and retail businesses.

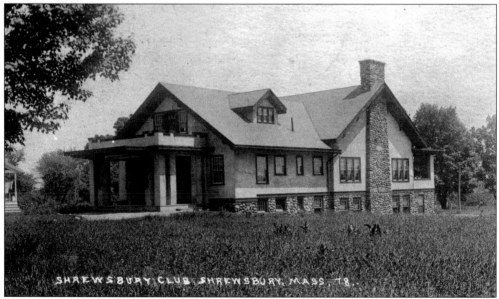

The Shrewsbury Men's Club was located at what is now 512 West Main Street. Built in 1905, the club was located on the site of the terrible Buck fire of 1902. This fire, in which two elderly women died, burned three houses and threatened the entire center of town. The Shrewsbury Men's Club, which had a bowling alley in the basement, was home to a wide variety of social affairs over the years. Eventually, the Shrewsbury Grange took over the building. It still stands and has been extensively remodeled.

16

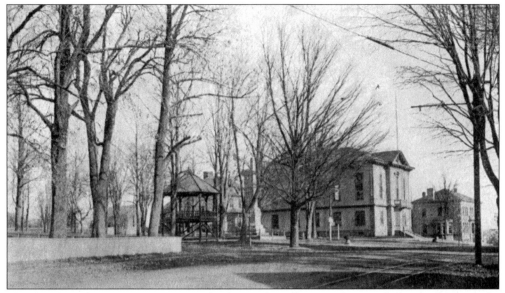

The bandstand on the town common has a long history, having been donated to the Shrewsbury Brass Band by the King's Daughters in the late 1800s. The bandstand has also been in at least one other location. This view of what was known as Park Square in the years before World War I shows the bandstand located just about even with the Soldier's Monument at the south end of the town common.

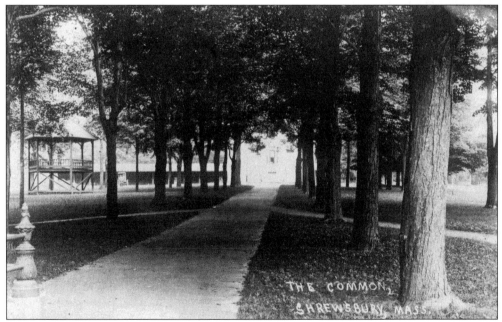

A message written on the reverse of this 1910 postcard reads: "I think of you often and hope you are enjoying these fine Fall days. The little church at the end of walk is where we attend services." The "little church" is the First Congregational Church. Also visible in this view is the bandstand, which had been moved north a few years earlier to the location shown, and the horse sheds that were used by people attending church. If you look closely through the trees, you can see a carriage in front of the sheds.

17

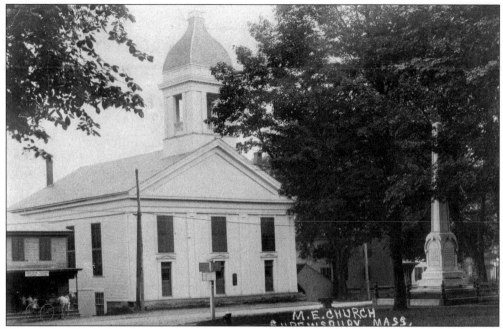

The Methodist church, which was located directly opposite the Civil War monument on the town common, was built in 1847. It stood on this spot for 75 years until it was torn down in June 1922. The red brick building once known as the George Block (more recently the Hale Block) stands on this site today. One story is that the horse sheds used by churchgoers were constructed with timbers from the old floating bridge that once spanned Lake Quinsigamond.

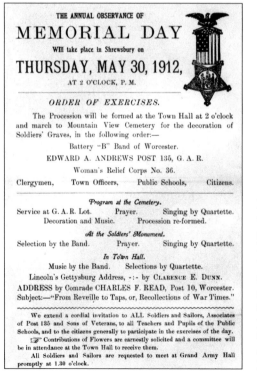

THE ANNUAL OBSERVANCE OF

MEMORIAL DAY

Will take place in Shrewsbury on

THURSDAY, MAY 30, 1912,

AT 2 O'CLOCK, P. M.

ORDER OF EXERCISES.

The Procession will be formed at the Town Hall at 2 o'clock and march to Mountain View Cemetery for the decoration of Soldiers' Graves, in the following order:—

Battery "B" Band of Worcester.
EDWARD A. ANDREWS POST 135, G. A. R.
Woman's Relief Corps No. 36.

Clergymen, Town Officers, Public Schools, Citizens.

Program at the Cemetery.
Service at G. A. R. Lot. Prayer. Singing by Quartette.
Decoration and Music. Procession re-formed.

At the Soldiers' Monument.
Selection by the Band. Prayer. Singing by Quartette.

In Town Hall.
Music by the Band. Selections by Quartette.
Lincoln's Gettysburg Address, -:- by CLARENCE E. DUNN.
ADDRESS by Comrade CHARLES F. READ, Post 10, Worcester.
Subject:—"From Reveille to Taps, or, Recollections of War Times."

We extend a cordial invitation to ALL Soldiers and Sailors, Associates of Post 135 and Sons of Veterans, to all Teachers and Pupils of the Public Schools, and to the citizens generally to participate in the exercises of the day.
☞ Contributions of Flowers are earnestly solicited and a committee will be in attendance at the Town Hall to receive them.
All Soldiers and Sailors are requested to meet at Grand Army Hall promptly at 1.30 o'clock.

In the era before World War I, veterans of the Civil War, many of whom were still alive, were held in high esteem. Memorial Day 1912 was a solemn tribute to the veterans who had passed away. Grand Army of the Republic Post No. 135 turned out to march and decorate graves. Teachers, schoolchildren, and the populace in general joined them. At this time, there were still 19 Civil War veterans living in town. With the death of comrade Peter Gamache in 1929, Post No. 135 passed out of existence.

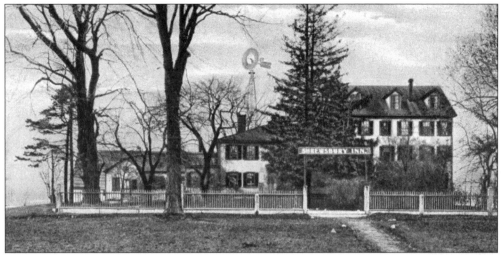

The house that would later become the Highland House was built in 1816. Samuel Haven, who operated the Cushing-Haven Tavern for many years, was its owner. Later, Civil War veteran Hiram W. Loring purchased the house. Loring had a three-story ell added to the house in 1888, turning what had been a private residence into a hotel called the Highland House, or Highland Farm House. The Highland House later became known as the Shrewsbury Inn. Later still, the ell was taken down and the hotel again became a private residence. It still stands on its original site between Route 140 and Prospect Street.

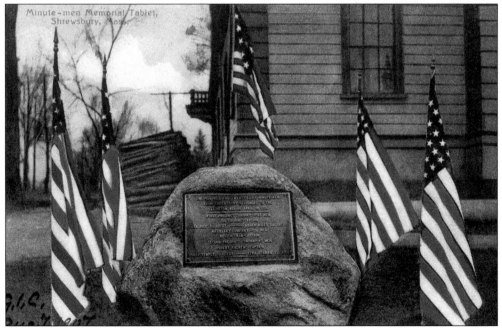

In November 1905, the Shrewsbury Historical Society dedicated this plaque to the 128 men from Shrewsbury who served in the Revolutionary War. Mounted on a boulder, the plaque was placed so as to be "near as possible on the spot where the local company formed for the march on Lexington." The monument was dedicated with a long ceremony, which included speakers from Shrewsbury, Worcester, Boylston, and West Boylston. The dedication was followed by a reception held in the nearby town hall.

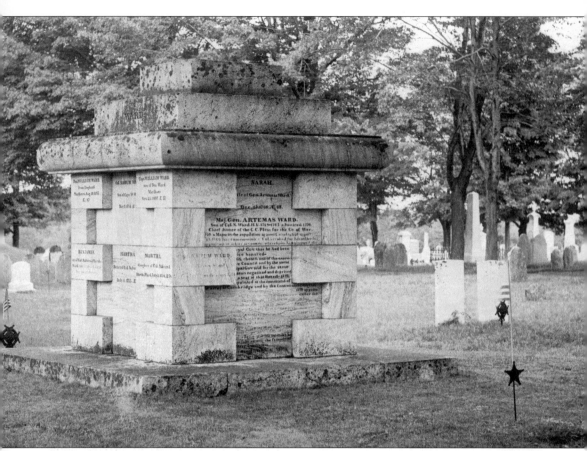

Maj. Gen. Artemas Ward was not only the first commander in chief of the Revolutionary army but also Shrewsbury's most illustrious citizen. When the general died in 1800 at the age of 72, he was buried in the Mountain View Cemetery. Around 1840, his tombstone, along with those of several other family members, was removed and made into part of the stone pillars at the cemetery entrance. A much larger monument was erected to memorialize the Ward family. The monument, shown here, includes inscriptions describing the lives of various members of the family. Of course, the most detailed information pertains to the general himself. Looking at the monument today, you will find that the inscriptions are greatly faded from the effects of the weather. One old story tells how Ward descendants would color in the lettering with black paint every year or two, a practice now forgotten.

When Shrewsbury's first minister, the Reverend Job Cushing, died suddenly in 1760, the search began for a replacement. Several candidates were interviewed before the church voted to accept the Reverend Joseph Sumner, who was ordained on June 23, 1762. A 1759 graduate of Yale College, Sumner purchased a house next to the town common. Reverend Sumner died on December 9, 1824, having served 62 years. In all this time, until he became infirm from old age, "the publick exercises of the Sabbath . . . were suspended only seven Sundays, on account of his indisposition, or in consequence of his journeying."

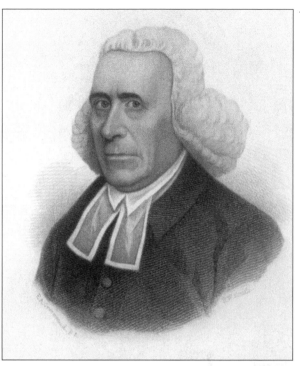

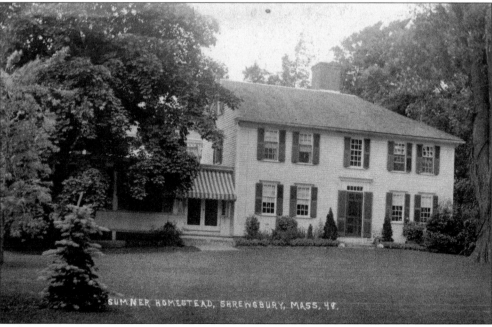

Built in 1797, the Sumner House was the home of Rev. Joseph Sumner, Shrewsbury's second minister. Standing on what was called the "Meeting House Land," this home remained in the Sumner family until the 1970s. Over the years, two additions resulted in the house having a total of 23 rooms. The dates of the house's construction and additions are cut into the mantel of one of the fireplaces. The Sumner House is located next to the town common and was recently turned into a bed-and-breakfast.

Commonwealth of Massachusetts.

TOWN OF SHREWSBURY.

TOWN CLERK'S OFFICE, June 30, 190...

In accordance with the provisions of the Laws of the Commonwealth of Massachusetts, license is hereby issued to

Dana L. Brooks,
Hospital Farm

to keep the **DOG** described in the margin until the first day of May, **1907.** Said dog is Numbered and Registered as required by said laws, for which two.......... Dollars have been paid.

Geo. E. Stone

TOWN CLERK

No. **80**

ne *Ponto*

4 yrs.............. mos.

Sex: male

ed *Newfoundland*

or *Black*

N. B.—"The owner or keeper of every dog so licensed shall cause it to wear around its neck a collar distinctly marked with its owner's name and registered number."
Dogs three months old or over must be licensed.

Spring is a time for planting flowers and gardens, cleaning yards, and generally getting out of doors. It is also the time when dog owners throughout the state must renew their dog's license. Shrewsbury canines are no exception, although the licenses of today are nowhere near as nice as this one from 1906. The license was for Ponto, a four-year-old black Newfoundland that lived at the Hospital Farm, which was located on what is now part of the Glavin Center property on Lake Street. This was one of 191 licenses issued for male dogs and 34 for female dogs that year. In addition to the cute puppies on the front of the license form, the reverse side was filled with information about the care and treatment of dogs. One bit of advice tells us that "the proper food of a dog is meat, bread, vegetables, and dog biscuit. Salt things, sweet things, ham bones, and chicken bones often cause indigestion and fits." Another section reviews the perils of hydrophobia. The license was signed by Shrewsbury's town clerk, George E. Stone. Ponto's owner, Dana L. Brooks, was the great-grandfather of retired town clerk Donald Gray.

Dr. Franklin Whiting Brigham—like his father, Adolphus—was a physician in Shrewsbury. Brigham was a Civil War veteran of the U.S. Navy The Sons of Union Veterans Camp in Shrewsbury was named after him. Known for his wisdom and kindness, Brigham was beloved by the townspeople he treated. He died in 1899 at the young age of 58. The Shrewsbury Historical Society preserves many of his belongings as examples of old-time medical tools and practices.

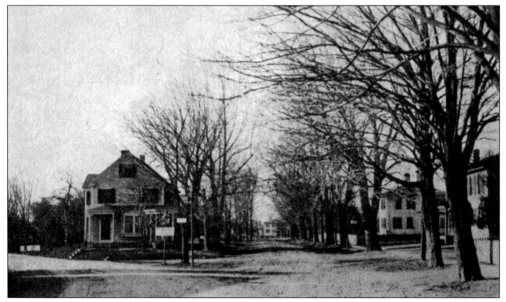

Brigham's Corner was named after Drs. Adolphus and Franklin Whiting Brigham, well-known Shrewsbury physicians in the 1800s. The Brigham house is to the right in this view at what is now 535 Main Street. Calvin Stone built the house *c.* 1822. A boiler explosion on the steamship *Mozelle* in Cincinnati, Ohio, killed Stone in 1838.

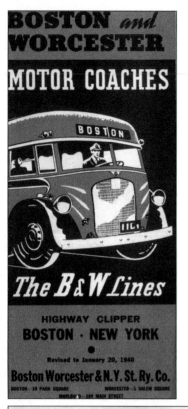

The Boston and Worcester bus line had two routes through Shrewsbury, one following Route 9 and the other branching off the turnpike at Fairlawn and continuing through Shrewsbury Center on the old Post Road. By 1940, the bus line was a booming business. It offered special trips to sporting events at the Red Sox and Bees' baseball parks, the Boston Garden, and the Boston Arena, in addition to "sea trips" to Provincetown or Nantasket Beach. The buses ran on the hour on the Post Road line and at half past the hour on the turnpike. By 1947, business had dwindled somewhat and, within a few years, the Boston and Worcester line ceased operations altogether.

For many years there has been a lot of discussion about heavy traffic in the center of town. This problem, however, is not new to the center of town. Almost as soon as the first automobiles came on the scene there were problems. Careless drivers crashed into buildings, people, and horses. Parking became an issue as people drove to the various stores or town offices. As the number of cars and trucks grew, so did the traffic problems. One means of controlling the traffic was in the form of a police box, shown standing in the intersection of Route 140 and Main Street *c.* 1950.

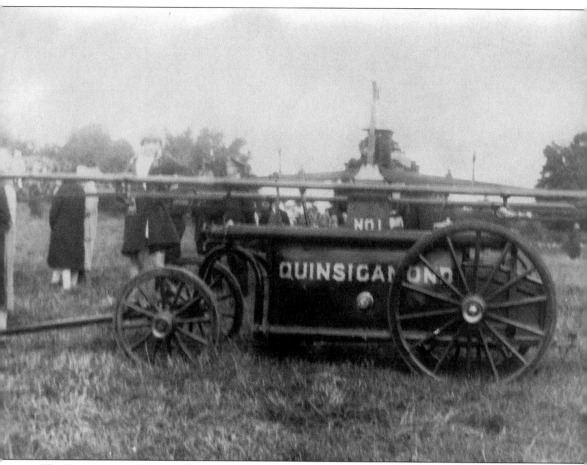

The Quinsigamond Engine Company was formed in 1850. The Fountain Engine Company was also formed. The two companies not only provided protection from fires but were social organizations too. They routinely held balls, dinners, and other affairs. The engines provided fire protection for the town until the early years of the 20th century. The Quinsigamond and Fountain engines were placed in storage on and off, making appearances at town events over the years. In the 1970s, they were restored through the efforts of the Shrewsbury Fire Department. The Quinsigamond engine is shown here on display at some type of town event, possibly the Charity Circus held in 1916.

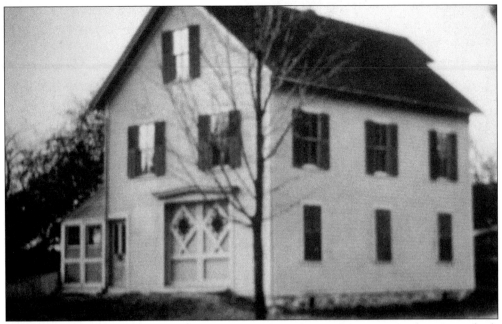

When the Quinsigamond Engine Company was formed in 1850, an engine house was built northeast of the town common, behind the Cushing-Haven Tavern. In 1896, this engine house was built to replace this first structure. It was located on the site of the present Shrewsbury Fire Department headquarters. For a few weeks in April 1902, a great scare ran through the town when it was thought that a ghost had taken up residence here. The *Boston Globe* even sent a reporter to investigate the spook, which turned out to be a practical joke.

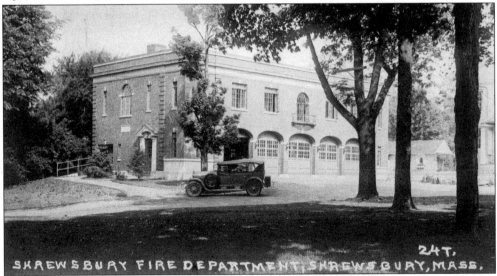

When the Shrewsbury Fire Department started to grow and modernize in the 1920s, a new building was constructed to house the department's men and equipment. The building, which was built in 1928, served both the fire and police departments until the current police station was built in the 1970s. When it was new, this building was a vast improvement over the previous arrangement, where two small stations housed the Quinsigamond and Fountain hand-tub engines.

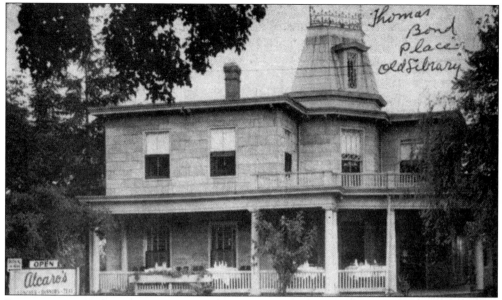

For many years, Alcaro's was a popular restaurant in Shrewsbury. The building it occupied in Shrewsbury Center had originally been known as the Gibson, or Thomas Bond Place. It was purchased by the town in 1894 and used as the town library. At that time, the building was located on the north side of Main Street. When the Howe Memorial Library was to be built, this building was moved up to the town center and, as Alcaro's, it stood just west of the Hale Block. Here we have an inside and outside view of the restaurant. The building burned down in the mid-1950s.

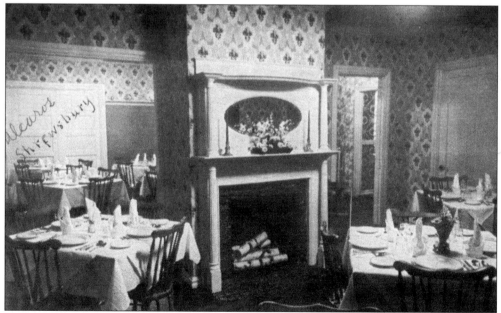

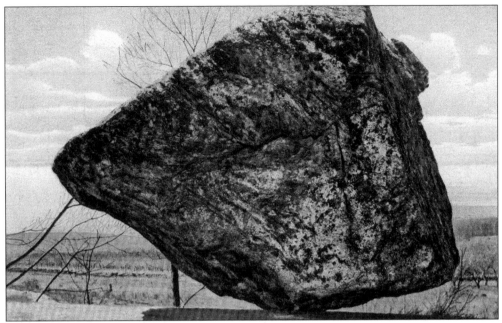

The Balance Rock, sometimes known as the Rocking Stone or Old Poet, was a popular local attraction years ago. More or less forgotten today, this huge rock was deposited on its resting place by a glacier. It was once so perfectly balanced that it could be rocked back and forth. Human nature being what it is, some early townspeople tried to pull the stone over with a team of oxen. This only set the rock more firmly in place, so that it ceased its rocking. The Balance Rock is located off of Route 140 near the Boylston line.

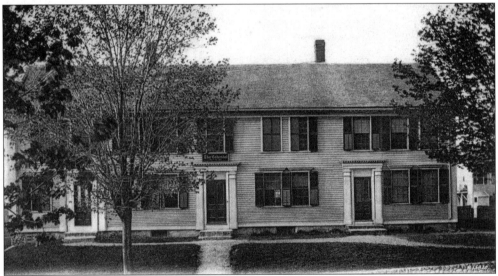

Built in 1751, the Cushing-Haven Tavern was the largest and best known of Shrewsbury's taverns. It was built by Col. Job Cushing, who was the son of Rev. Job Cushing, the town's first minister. It is reported that the minutemen answered the call to arms here in April 1776. In 1871, the tavern was removed to make way for the new town hall. It was removed in three sections. Shown here is the main section, which was moved across Main Street, where it stood until 1960.

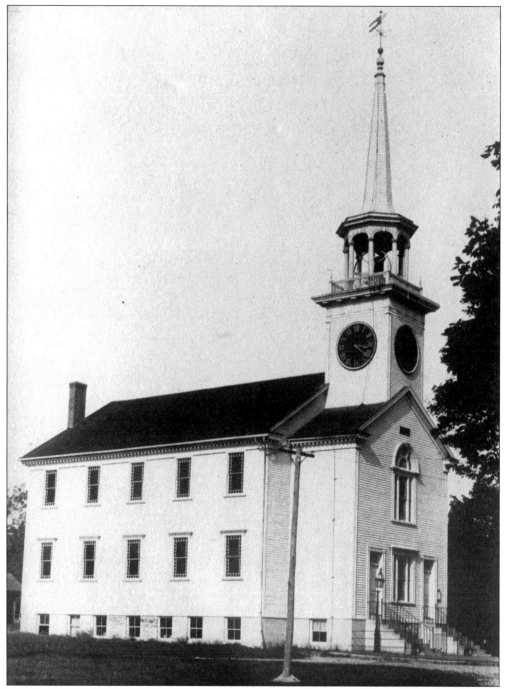

The First Congregational Church was organized in 1723 and had 16 members. The first meetinghouse had only one room and measured 40 by 32 feet. The current church was built in 1766. The building was improved and enlarged over the years. In 1807, a steeple was added and, in 1834, the building was turned to face south and was moved to the north about 50 feet to its present location. Later, a vestry and large hall were added with a very recent large addition to the rear of the building. This view shows the church as it appeared between 1834 and 1891.

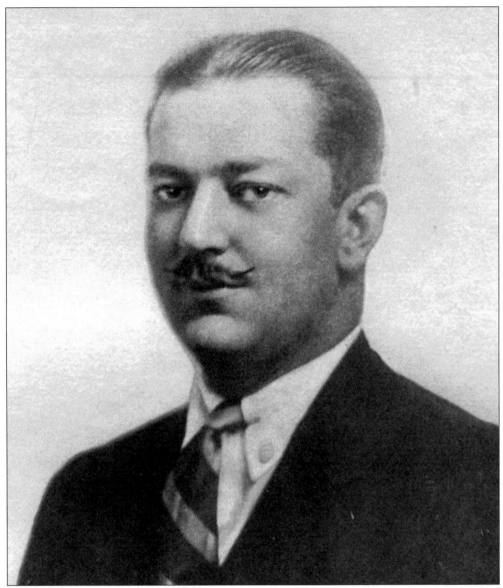

Homer Gage Jr. was born in Worcester on November 17, 1895, the son of Dr. and Mrs. Homer Gage. He was a member of a prominent family and was educated accordingly, entering Harvard in 1914. His education was interrupted during World War I, when he served in the American Field Service in an ambulance company. He then secured a position through the good graces of his uncle L.J. Knowles of the Crompton and Knowles loom works. Gage soon moved into a management position with his uncle's firm, but he had a passion for dogs. When he asked his parents if he might start a kennel, they gave him permission to do so, with the condition that he study the subject seriously enough to be "recognized as a real factor in the dog world." He opened the Welwire Kennels, where he raised Welsh and wire-haired fox terriers. He became a well-known expert in dog-breeding circles throughout the world. At the age of 30, he was stricken ill with infantile paralysis and was dead within three days. A monument was later dedicated to him, located at the intersection of Elm Street and Route 9.

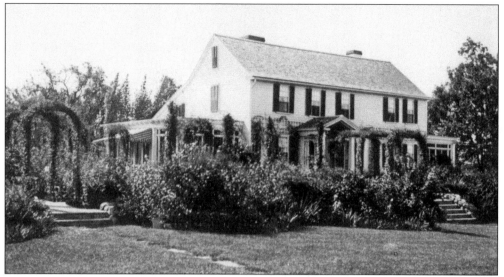

Iristhorpe was the home of Dr. and Mrs. Homer Gage. It was known for its elaborate gardens and beautiful irises. The house was possibly built as early as 1719. It was enlarged in 1752, when Dr. Edward Flint owned it. The house was moved about 500 feet, at some point, from where it originally stood facing Main Street. The Gages' son Homer Gage Jr. might have carried on with the estate had he not died within a few years of returning from service with the U. S. Army in World War I. In this view, we can see some of the estate's beautiful landscaping.

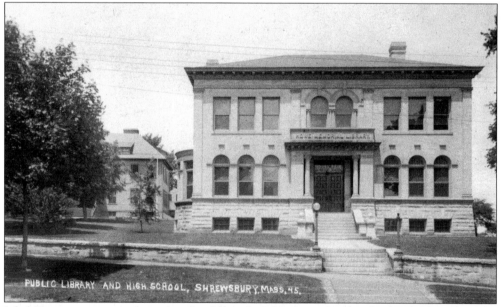

PUBLIC LIBRARY AND HIGH SCHOOL, SHREWSBURY, MASS, 45.

Jubal Howe was a young boy when his father died, leaving a family of eight children. In order to help support the family, young Howe went to work, learning the trade of watch making from Shrewsbury's well-known watchmaker, Luther Goddard. Howe was successful in the jewelry business and eventually left the town a bequest "for the purpose of establishing or maintaining a Free Public Library in said town for the benefit of the inhabitants thereof." Built in 1903, the Jubal Howe Memorial Library has been modernized and enlarged over the years and is still serving the needs of the town.

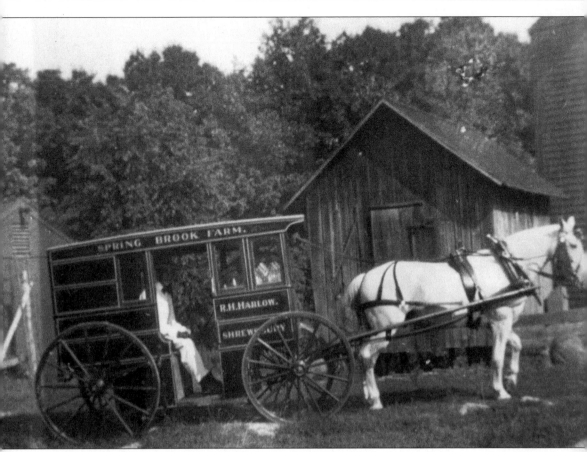

This wagon was used by Robert H. Harlow in his Spring Brook Farm milk business. It is shown here in 1910, a few years after the business was started. It was about this time that the business was moved from Gulf Street to Prospect Street. Harlow would buy milk from many local farmers, process it, and then deliver it throughout the town and even into Worcester. Trucks replaced the horse and wagon in the mid-1920s. The business was sold in 1946.

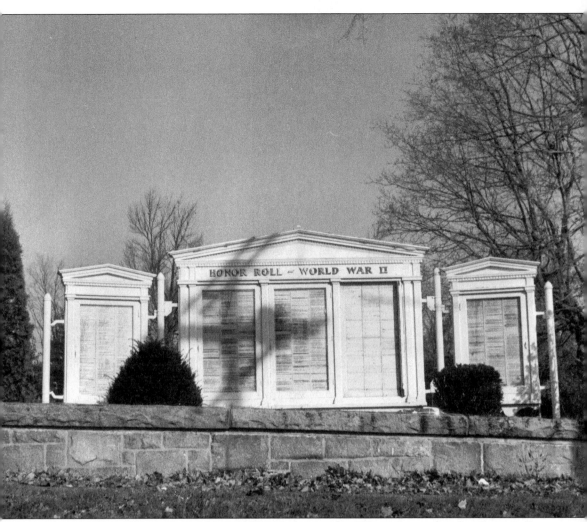

When the United States entered World War II, the people of Shrewsbury erected an honor roll in the center of town. This was modeled after a similar honor roll for the Shrewsbury veterans of World War I. The World War II version was much larger than its predecessor. By June 1945, it listed 970 names and was still growing. Although it was difficult to keep the names up to date, the effort itself was noteworthy. Each military member's name was hand-lettered onto a metal strip, which was then inserted in alphabetical order on one of the honor roll's three panels. The honor roll stood in the area near where the new library addition is, facing Main Street. Many years later, the honor roll was dismantled.

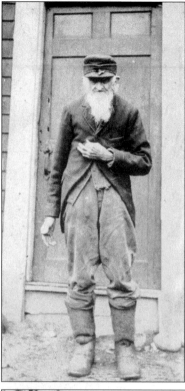

Erastus Wheelock was born in 1822 on his family's farm. When he died at the age of 88 in 1906, he was the fourth generation of his family to live on the homestead. At the time of his death, he was the oldest man living in Shrewsbury. He was a member of the First Congregational Church for 68 years and served as the superintendent of the Sunday school for 29 years. He was described as being "interested in all the affairs of the church and town" right until he died.

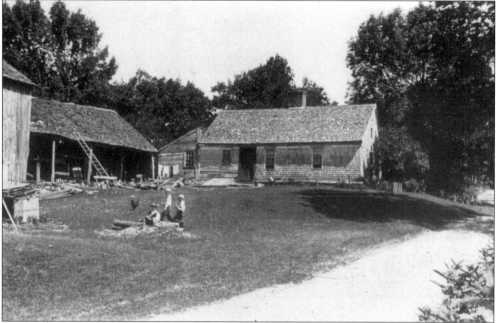

Gershom Wheelock was the first settler in Shrewsbury, moving here in the winter of 1717. This is the house he built in 1732, at what is now 265 Boylston Street. The picture was taken c. 1895. By 1937, the Wheelock family had occupied this house continuously for 205 years through five generations. It was used as an antique shop for a time and is now a private residence.

Two

SCHOOLS

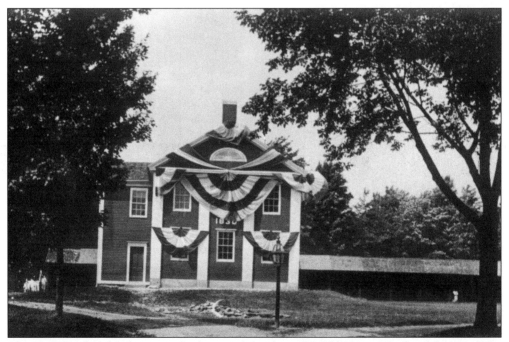

The 1830 Brick School was nicely decorated for the 1907 Old Home Week celebration. The horse sheds used by members of the First Congregational Church can be seen in the background. The sheds were torn down c. 1912. The Shrewsbury Municipal Employees Credit Union occupied the lower floor of the school for many years, with the town's historical society using the upper floor. The Shrewsbury Historical Society now occupies the entire building. (Courtesy Shrewsbury Historical Society.)

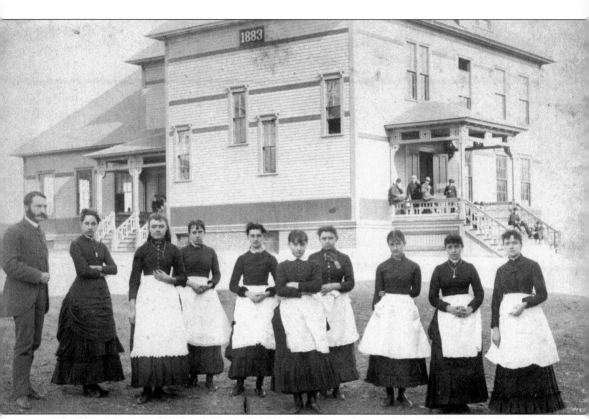

The Shrewsbury High School Class of 1885 is shown standing in front of the school, which was built in 1883. To the left is Dorran B. Cox, the school's principal. The woman standing next to him is probably his wife, Louise, who served as his assistant. The graduates are, from left to right, as follows: Cyrene Flint, Clara Winchester, Minnie Dearth, Imogene Mitchell, Ella Keegan, Jennie Reed, Jessie Rice, and Alice Kelly (the original owner of this photograph). The six surviving members of the Class of 1885 held a 50th reunion on June 19, 1935, at the home of Jessie (Rice) Prarie.

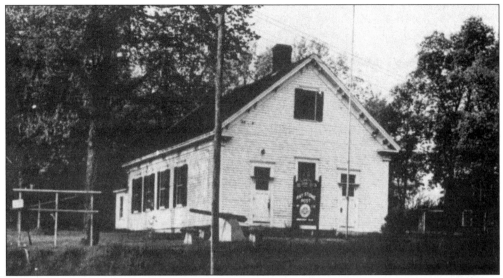

Dedicated in 1858, this building was the third schoolhouse to be known as No. 2. The first is supposed to have stood nearly opposite the Pease Tavern. The second is described in one account as "a square, hip-roof, one story building with a cupola." Around 1846, this schoolhouse was raised and a first floor was added. In 1858, the building was moved to a site between Walnut Street and Harvard Avenue. The present building has served for many years as home to the Ray Stone Post of the American Legion. More recently, the Shrewsbury Grange and Victor Quaranta Post have also used the building.

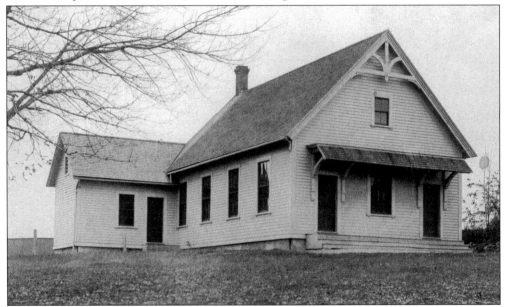

The No. 3 School District had one of the first schoolhouses in town. The early schoolhouse was built with funds from private individuals but was purchased by the town in 1798. It stood near the corner of South Street and what is now Route 20 until 1884, when it was torn down. This photograph shows the new No. 3 School, built in June 1884. It was used until 1930, when parents of the remaining 13 or so pupils asked to have their children sent to school at the town center. The No. 3 School property was taken by the state when Route 20 was built in 1931.

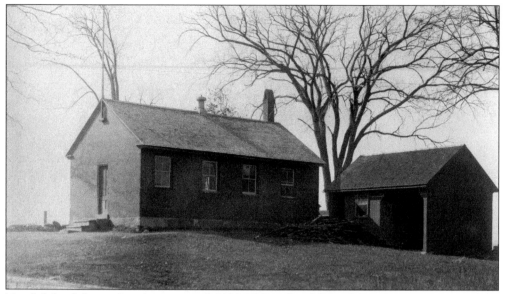

No. 5 School, located at the corner of Old Mill Road and West Main Street, was one of the town's district schools. A building may been built as early as 1805, but the school was certainly in existence by 1815. George Stone, who served as the town clerk, reported this in a paper written in 1900. This particular school was reported to have been built in 1828. No. 5 was last used as a school in 1917. Following that, a ward of the town lived in the building for many years. The school building was obtained by the Shrewsbury Historical Society in 1974.

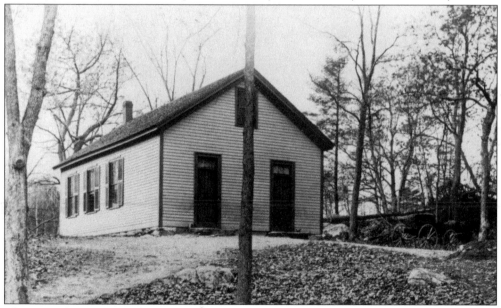

The original No. 6 School was built *c.* 1798, according to a paper written by historian George Stone in 1900. It was replaced by this building in 1856. This school was located on Boylston Street, just about opposite the intersection with Hill Street. H.S. Shepard bought the little school building from the town in July 1926. He had plans to refurbish the building and make it into a house. The building burned to the ground on January 5, 1928, the fire being attributed to vandals who had broken in.

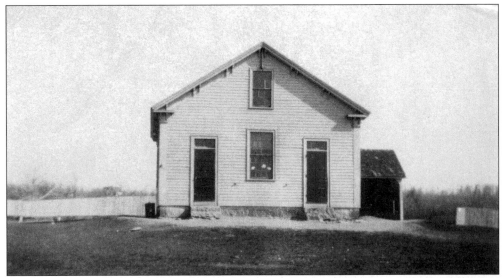

The first No. 7 School was built in 1808 and stood near what is now the corner of Route 9 and Crescent Street. The school was either moved or another building was erected just to the east of what is now the corner of Lake Street and Route 9. By 1884, the town reported the school to be in bad condition, requiring painting and renovating. The grounds were described as "cold, wet, and malarious." Years after the school closed, it was home to a sportsman's club and then a veteran's post. The building eventually burned.

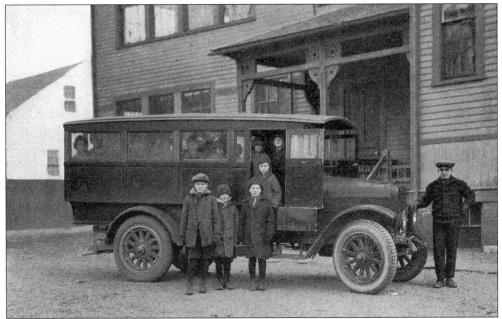

When the town used the district school system, most pupils lived fairly close to their particular school and walked to and from classes. Later on, students needed transportation to the town center. This "barge" provided transportation for elementary and high school students on Boylston and Barnard Streets as well as elementary students from the Lake section of town. A second bus brought junior and senior high school students from the area of town near the Henry Harlow School.

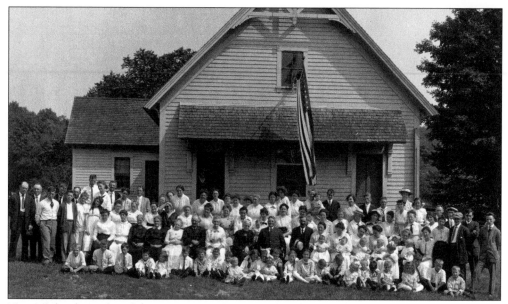

No. 4 School stood at the intersection of Grove and Grafton Streets for most of its existence but was moved several times in its early years. Starting in 1910, annual reunions were held every August, continuing for 35 years. These reunions were sizable affairs. At the 1915 gathering pictured here, 135 people sat down to dinner with many more eating on the lawn. The main speaker was Judge Harrington Putnam, a justice of the Supreme Court in New York and probably No. 4 School's most noted alumnus. No. 4 was last used as a school in 1930. The building was later damaged by a fire and was eventually torn down.

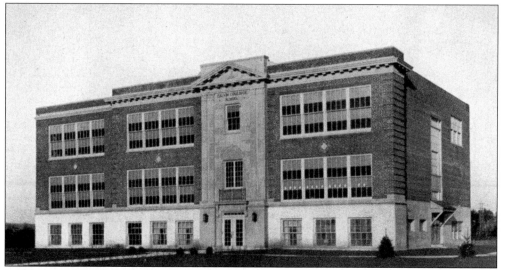

Problems involving overcrowding of Shrewsbury schools are nothing new. In the 1920s, the Bigelow School burned down, followed by a fire at the Ward School. A short time later, the new Calvin Coolidge School was completed. It had been anticipated that this brand-new building would be a solution to the space issue, but the loss of the Bigelow School and repairs required at the Ward School created a situation that required more room before the new school was even finished. The school has been modernized and expanded a number of times and now looks quite different than it does in this early view.

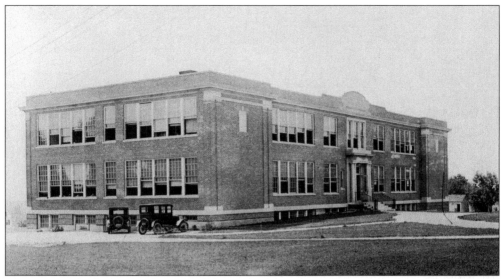

This view of the high school was taken by Herbert Buxton in 1923, when the building was still new. The Major Howard W. Beal High School was named after a U.S. Army doctor who died in France on July 18, 1918. The school's gymnasium was named Nee Hall after Pvt. Michael Nee, who was killed in action on the same day Beal died. A few years after it was built, the school developed cracks in its brickwork, requiring large-scale repairs. This building was used as the high school until 1959, when the new high school on Oak Street opened.

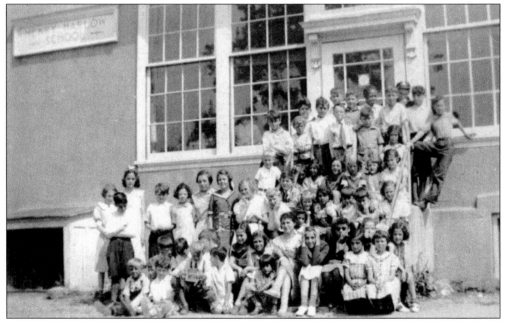

The Henry Harlow School was built in 1919 in an effort to accommodate the growing number of schoolchildren in the Morningdale and Lake Quinsigamond areas of town. It served for many years but was eventually closed when it was felt to be outdated. When the schools became overcrowded in the 1960s, the Henry Harlow School was once again put into service for a short time. The building was torn down in 1990. The sign for the Henry Harlow School can be seen on the left of this June 1936 photograph.

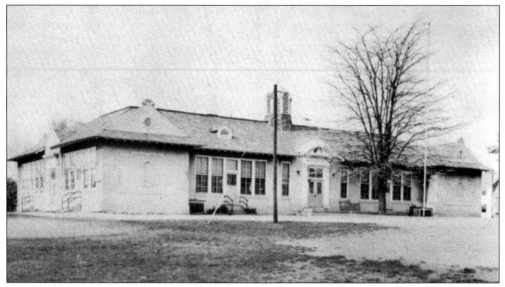

Shrewsbury experienced a large growth in population in the early 20th century. As a result of many families settling in the Lake section of town, a larger and more modern school was needed. The Artemas Ward School was built in 1917 to meet this need. Named after Shrewsbury's most illustrious citizen, the school was built as a "bungalow schoolhouse," which was the only one of its kind in the area. After serving the town for over 60 years, the Artemas Ward School was sold to Spag's Supply and transformed into "Spag's Schoolhouse."

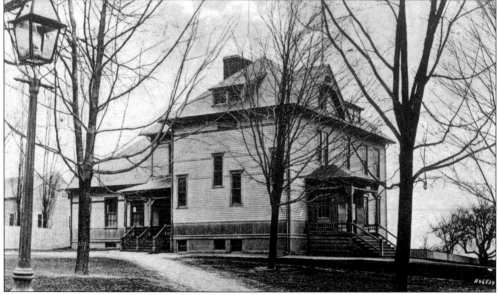

The Center School was built in 1883 to provide a more modern high school building for the town. After having attended one of the small district schools or the 1830 Brick School, the students must have found the new building a vast improvement. The school served in its high school role until the much larger Beal School was opened in the 1920s. The Center School continued to be used until the late 1950s, when it was closed. It was reopened in 1961 and served until the junior high school was opened. The Center School, which stood where the library parking lot is today, was later torn down.

Three
THE LOWER VILLAGE

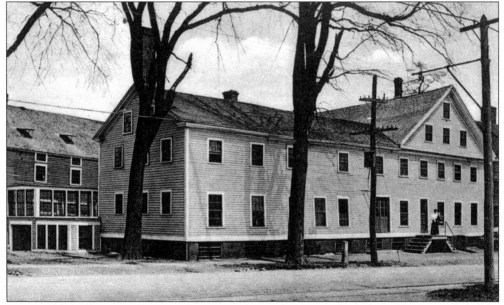

First established in 1803 by Nymphas Pratt, this tannery was Shrewsbury's largest industry for many years. The operation was updated to incorporate improvements in technology over the years. These ranged from horse-driven machinery to steam power and, later, more modern equipment. Business was very good during the Civil War, when leather products were supplied to the Union army. The business changed owners over the years and expanded to include plants in Winchendon and Grafton. Last known as the Hickey Leather Company, the business eventually closed and the building was torn down.

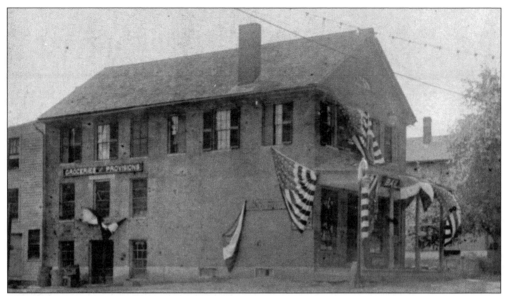

This brick building, built c. 1830, stood on Main Street at the corner of South Street. The lower level housed a country store run by Simon Allen. The upper part of the building was a little factory for production of ready-made clothing. Charles O. Green was a later owner. By the time this photograph was taken in 1907, the Bailey Brothers ran the store. It was later known as the Community Store and still later as Julio's Market. The building was torn down when a more modern Julio's Market was built. (Courtesy Shrewsbury Historical Society.)

From 1874 to 1897, Walter Warren operated the Shrewsbury and Worcester Stage and Express. Warren owned a stable located in what was then called the Lower Village. His stages were a primary means of transportation between Shrewsbury and Worcester. The trip between the post office in Shrewsbury Center and Front Street in Worcester took one hour. The passenger business ended when the first trolleys started running in Shrewsbury in 1897, although the express business continued. It was eventually sold to William Hickey, who operated it for some time.

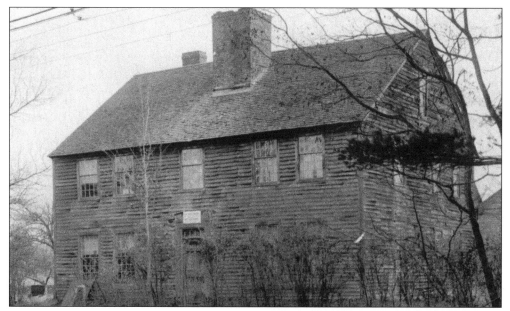

Maj. John Farrar, a veteran of the Revolutionary War, built the tavern at the corner of Main Circle and Walnut Street. It is variously reported as having been built in either 1751 or 1776. It was here that Gen. George Washington stopped on his way to Boston in 1789. In 1793, Levi Pease, known as the "Father of the Stages," bought the tavern, and it has been known as the Pease Tavern ever since. The original tavern had several interesting features but has been altered a number of times over the years.

Built c. 1790, the house at 677 Main Street was the home of Jason Ware. The house was known either as the Jason Ware Place or Sycamore Lodge, the latter name coming from two large sycamores in front of the house. In this 1910–1920 view, we can see the gazebo, which still stands in the yard. Dr. Azor Phelps, who married Ware's daughter Ann Janette, later lived in this house. Phelps was known locally for his Dr. Phelps Arcanum, a patent medicine that he produced in the years before his death in 1843.

Artemas Ward was born in Shrewsbury in 1727, the same year the town was incorporated. This is only fitting, as he went on to become the town's most notable citizen. A 1748 graduate of Harvard College, Ward went on to have a distinguished career in the service of his town, state, and country. He held many civic offices and was highly respected. He was appointed as a major general and was the first commander in chief of the Revolutionary army. Ward died in 1799 at the age of 72.

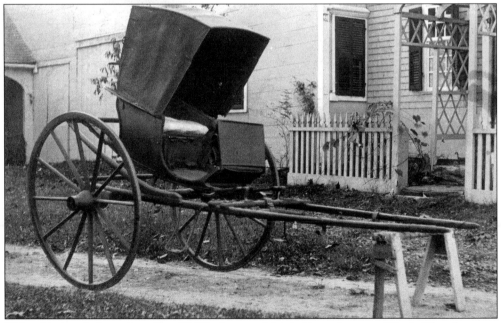

This old shay belonged to Sheriff Ward, son of Maj. Gen. Artemas Ward. The shay was constructed *c.* 1800 and remained in the Ward family for many years. It was a featured attraction in the 1907 Old Home Week parade. A newspaper account described it at the time as "very narrow and but one person can ride in it." Samuel D. Ward, who was more than 80 years old at the time, rode in the shay during the parade. The old shay has been preserved at the Artemas Ward Homestead Museum.

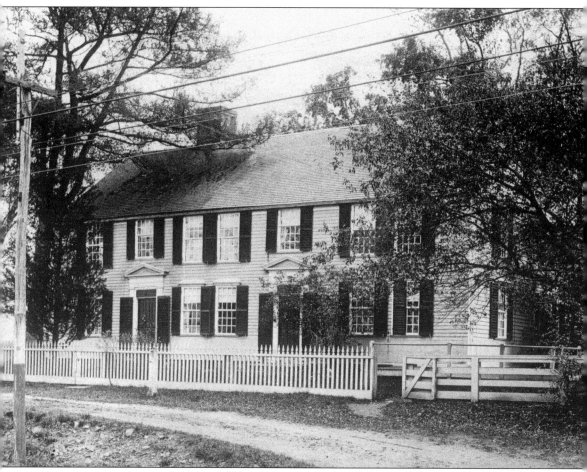

For many years, this was the home of Maj. Gen. Artemas Ward. Many of the general's belongings can still be found on display here. The general's father built the original, or east, part of the house in 1727. The west part was built in 1785, and it was here that the general lived. Then the general's son Thomas occupied the older portion. Many years later, the Artemas Ward Homestead was given to Harvard University to be preserved as a museum. Although much of the farmland that belonged to the estate was sold off, the house and barn are still intact. Many of the general's belongings, along with those of his family, are preserved there today.

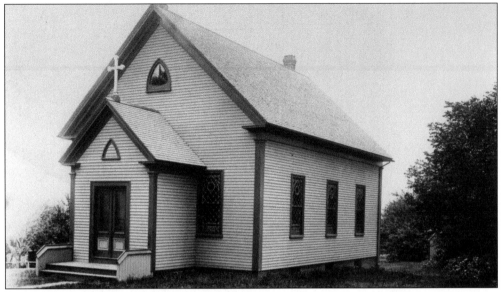

Prior to 1866, the Roman Catholics of Shrewsbury traveled to services in Worcester. Starting in that year, they met in the Fountain Engine House in the Lower Village. This was followed by services in the larger hall at the Cushing-Haven Tavern in Shrewsbury Center. In 1872, a small plot of land was purchased from Josiah Stone, and St. Theresa's Church was built. Shown here, the little church served until the congregation outgrew it and the much larger St. Mary's Church was built in 1923. The building was later converted to private use.

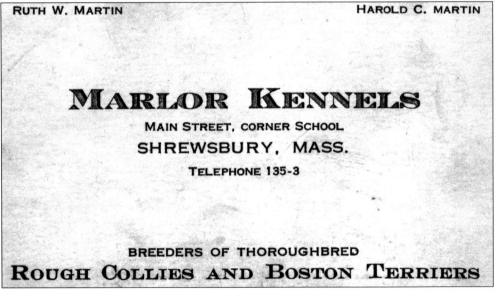

This 1925 business card advertised Harold and Ruth Martin's Marlor Kennels. The card probably would have been thrown out long ago, except for one fact—there is a handwritten message on the reverse side of the card. In 1925, Harold Martin was also the scoutmaster of Shrewsbury Troop 1 of the Boy Scouts. The message might have been part of some required training for the Boy Scouts involved. It reads: "This is to certify that Scouts Holbrook and Manning called at my house Sunday afternoon 2/1/25 at about 5:45. Harold C. Martin S.M., Troop 1, Shrewsbury."

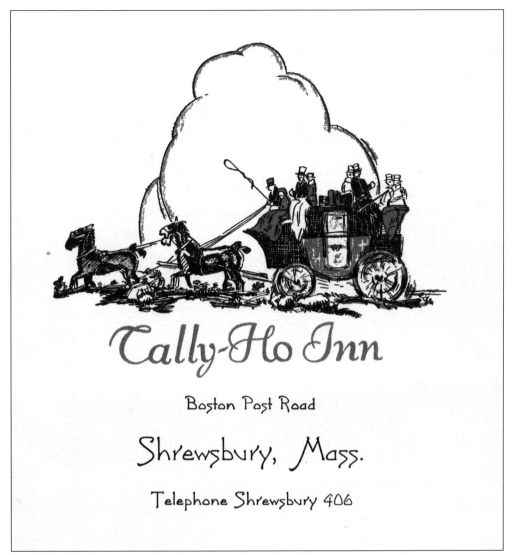

Tally-Ho Inn

Boston Post Road

Shrewsbury, Mass.

Telephone Shrewsbury 406

The Tally-Ho Inn operated in Shrewsbury during the 1930s. Located in what is now a private residence at the Bonnie Dell Farm on Main Street, the inn was run by Mildred Thornby. We may presume that she autographed this particular menu on October 8, 1939. The Tally-Ho Inn had quite an interesting menu. It must have been well known for its hot butterscotch rolls, as these were a part of every menu offering. In addition to lunch and dinner, afternoon tea was served. This consisted of assorted tea sandwiches, ice cream, and tea or coffee for 50¢. On this particular date, the daily special featured a choice of soup, tomato juice, grapefruit juice, a choice of meat or fish, french-fried potato, vegetable, salad, dessert, coffee, and butterscotch rolls. Although the business closed and the property was sold c. 1940, the wrought-iron Tally-Ho Inn sign was preserved and still occupies a space over the household's fireplace.

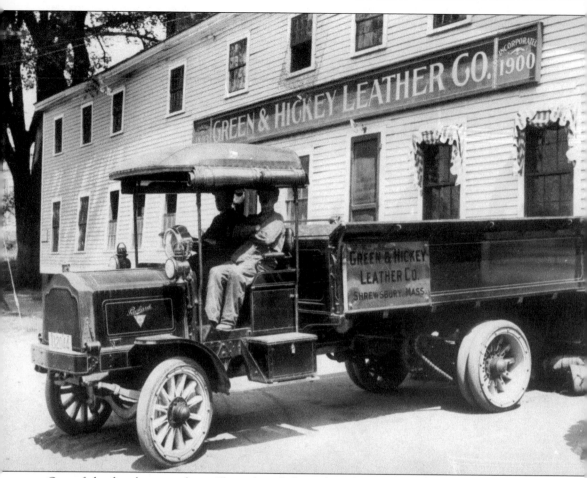

One of the first large trucks in Shrewsbury belonged to the Hickey Leather Company. This huge Packard truck was driven by Charles C. Garganigo, who is shown behind the wheel. The truck had an open cab and solid tires. Garganigo later went on to become an expert Pierce-Arrow mechanic. During Vice Pres. Calvin Coolidge's visit to Shrewsbury in the early 1920s, one of the automobiles in his entourage broke down. As the vehicle was a Pierce-Arrow, Garganigo was sent for. Accompanied by his young son, Albert (known as "Lovey"), he repaired the vehicle and saved the day.

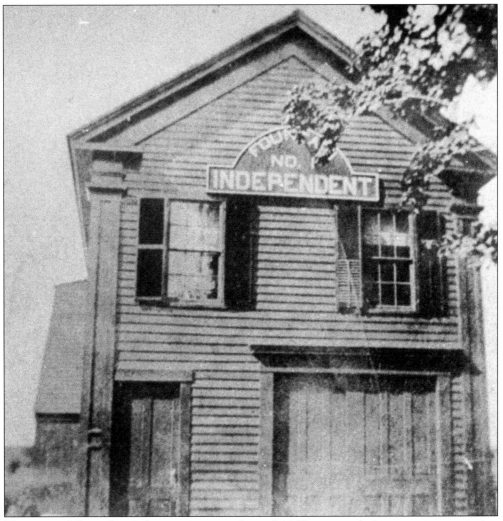

The town of Shrewsbury's fire protection in the mid-1800s consisted of two engine companies. The Quinsigamond Engine Company was housed in the engine house that once stood on the site of the present fire headquarters. The Fountain Engine Company was kept in another engine house on South Street in what was then called the Lower Village. The Fountain Engine was purchased through private subscription and arrived in town May 3, 1851. Members of the Quinsigamond Engine Company escorted the Fountain Engine through town. The company was also a social group holding balls, banquets, and musters with other groups. One such banquet included toasts, singing by members of the company, a pool tournament (a pool table was in the upper hall of the engine house), and a speech by Henry L. Goddard. Goddard declared that the Fountain Engine Company "had more fun to the square inch than any company on earth!" The Fountain Engine and engine house were used for many years. The little engine house was finally torn down, but fortunately the Fountain Engine itself has been preserved by the efforts of the Shrewsbury Fire Department. The engine house stood on the land near what is now 25–27 South Street.

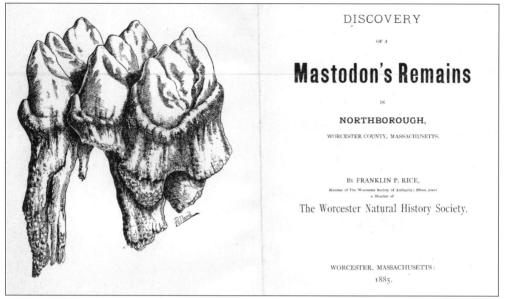

DISCOVERY

OF A

Mastodon's Remains

IN

NORTHBOROUGH,

WORCESTER COUNTY, MASSACHUSETTS.

By FRANKLIN P. RICE,

Member of The Worcester Society of Antiquity; fifteen years
a Member of

The Worcester Natural History Society.

WORCESTER, MASSACHUSETTS:
1885.

In 1884, William U. Maynard was having a deep trench dug in order to improve the drainage on his farm. His farm was located on the north side of Main Street at the town line with Northborough. As the work progressed, the workmen made a startling discovery—the remains of a mastodon. Although the bones of the beast had mostly crumbled into dust, nine large teeth and a few bone fragments were pulled from the soil. The mastodon's teeth were donated to the Worcester Natural History Society and were on display for many years.

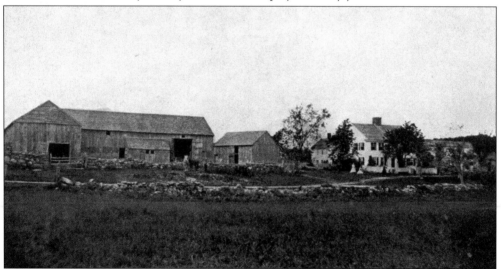

Ross Wyman moved to Shrewsbury in 1749. At that time, he purchased a farm of 160 acres located on both sides of what is now Main Street. As a skilled blacksmith and gun maker, Wyman built a dam and mill on a stream located on the southern side of the road. Although some buildings stood on the land when he purchased it, he soon built a fine new home, which is shown here. Wyman was an ardent patriot and made his feelings toward English rule quite clear. During a trip to Boston, several British sailors confronted Wyman. He beat them off by grabbing a codfish he was carrying home, hitting them with the fish's tail while holding it by the gills.

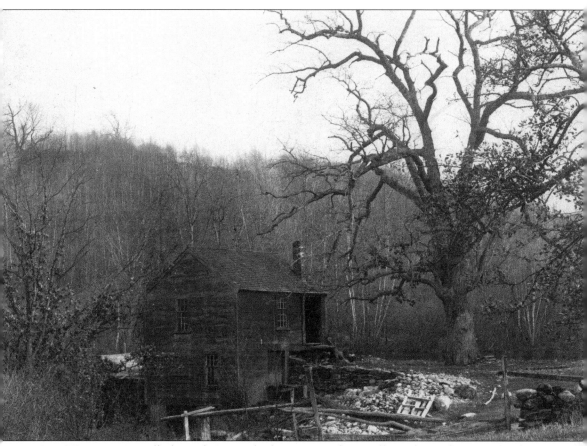

Ross Wyman's gristmill, shown here, was built *c.* 1800 and was still standing as late as 1927, the last of the many mills that once stood on Shrewsbury streams. Wyman worked the mills in addition to being a skilled gun maker. At the start of the Revolutionary War, Gen. Artemas Ward asked Wyman to make him a gun "of sufficient strength to pitch an Englishman over his head," according to Elizabeth Ward's book *Old Times in Shrewsbury*. The job was completed in fine style. Ward goes on to say, "He made it to order and of horse nail stubs, a real kings-arm and an excellent weapon."

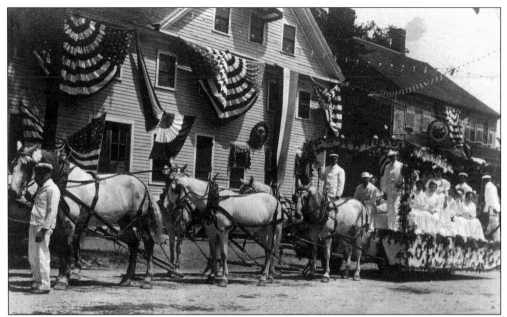

In 1907, Shrewsbury held its Old Home Week celebration. This event featured a parade, fireworks, dances, music, speeches, and many other activities. Pictured here is one of the many elaborate floats that appeared in the parade. This particular float was sponsored by the Shrewsbury Grange No. 101 and was bedecked with flowers. The photograph was taken in front of the Hickey Leather Company at the intersection of Main and South Streets.

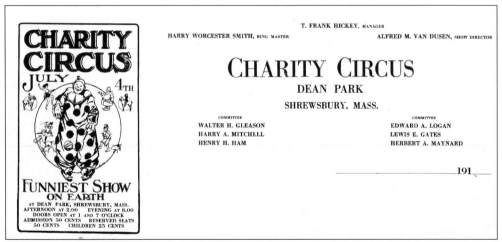

In July 1916, Dean Park was home to a charity circus run by the Ladies Charitable Society. The scene was described in the newspapers as looking "every bit like a circus grounds, with its large tent with all the banners flying, the side-show tent with its multicolored banners showing the monstrosities and freaks that were supposed to be on the inside." At the time, it was claimed that the circus was "one of the best and biggest events ever held in Shrewsbury." (Courtesy Shrewsbury Historical Society.)

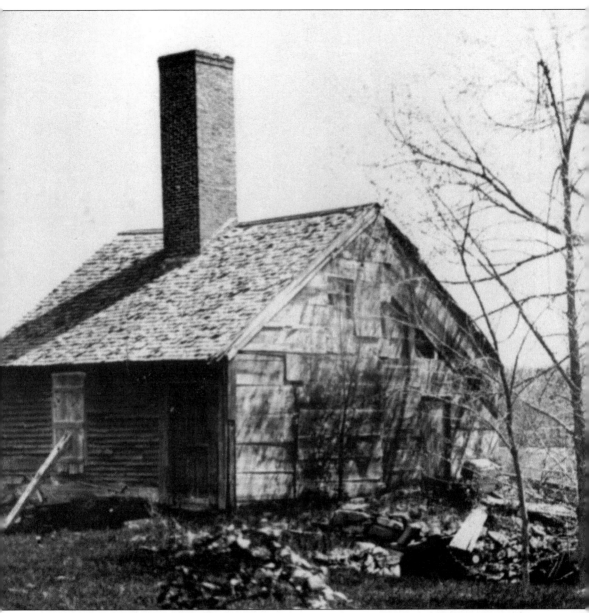

Sometime after Henry Baldwin bought the house of Nahum Ward in 1755, he added this ell onto it. In 1805, Samuel Bullard bought the property, now part of Dean Park. This would become the scene of the grisly murder of John Bullard. John Murphy was a young man who worked at the leather company in the Lower Village. He was known to frequent several establishments that served hard liquor. In 1876, John Murphy visited the Bullard house to buy a drink of hard cider. When Bullard refused to serve him, he became enraged. He picked up a hatchet and struck Bullard a number of times, killing him. Murphy was convicted and spent years in prison, until being released due to illness. He died a few months after gaining his freedom, nine years after the murder, in 1885. (Courtesy Shrewsbury Historical Society.)

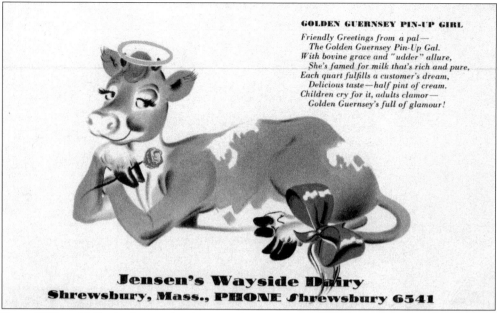

GOLDEN GUERNSEY PIN-UP GIRL

Friendly Greetings from a pal—
The Golden Guernsey Pin-Up Gal.
With bovine grace and "udder" allure,
She's famed for milk that's rich and pure,
Each quart fulfills a customer's dream,
Delicious taste—half pint of cream.
Children cry for it, adults clamor—
Golden Guernsey's full of glamour!

Jensen's Wayside Dairy
Shrewsbury, Mass., PHONE Shrewsbury 6541

From 1913 to 1963, the Jensen family ran a dairy, restaurant, and ice-cream bar at 745 Main Street. The dairy's motto was "Just a Little Bit Better." Jensen's delicious ice cream became known far and wide. The blotter features the Golden Guernsey Pin-up Girl, advertising what was surely one of Shrewsbury's most popular spots. (Courtesy Nancy [Jensen] Devin.)

Four

SOUTH SHREWSBURY
AND THE TURNPIKE

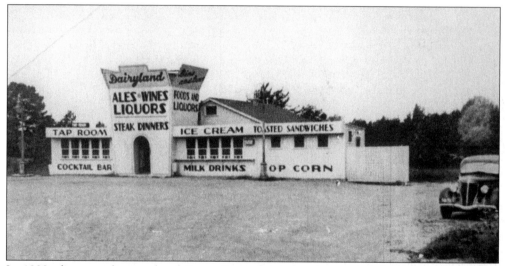

In 1932, the recently completed Route 9 was fast becoming one of the area's most heavily traveled roads. Hoping to take advantage of the large number of potential customers passing by, a man named Mickey Green opened a roadside stand called Dairyland at the corner of Route 9 and Lake Street. Green, who was well known as a boxer, built a unique structure in the shape of an ice-cream box with the top flaps open. With the number of people owning cars steadily increasing, the business soon prospered. When Prohibition ended in 1933, the business obtained a liquor license and started serving drinks. Ice cream was still available at a take-out window. The Hurricane of 1938 damaged the building, with the flaps of the ice cream box being blown off. In the early 1940s, the popular Dairyland was transformed into a nightclub named after its owner, Mickey Green's. The business was sold in 1977, becoming Joie's nightclub. A few years later, it was torn down to make way for a car wash and maintenance complex. (Courtesy Donald Green.)

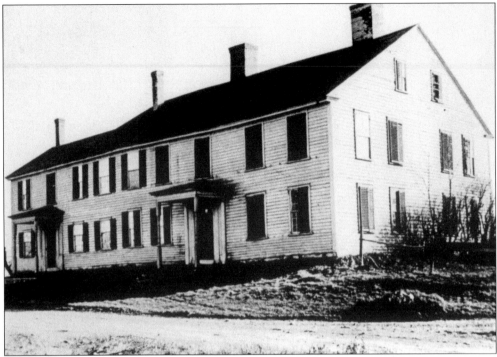

The Arcade Tavern stood on the corner of the Boston and Worcester Turnpike and what is now Lake Street. Also known as the Old Arcade, this tavern was built to cater to travelers along the turnpike. As the years passed and business dwindled, the Arcade Tavern was closed as a tavern. It is shown here in its later years, looking to be in very poor repair. The Arcade Tavern was torn down to make way for Route 9 in the early 1930s.

This road sign once stood at the corner of the Boston and Worcester Turnpike and Grafton Street. It was located on the edge of what Elizabeth Ward described in her 1892 book, *Old Times in Shrewsbury,* as "the common surrounded by beautiful maple trees." Known in those days as the South Common, this was the location of the First Restoration Society, or Universalist church. The church was built in 1823 and was active at intervals until 1868, when the society was dissolved.

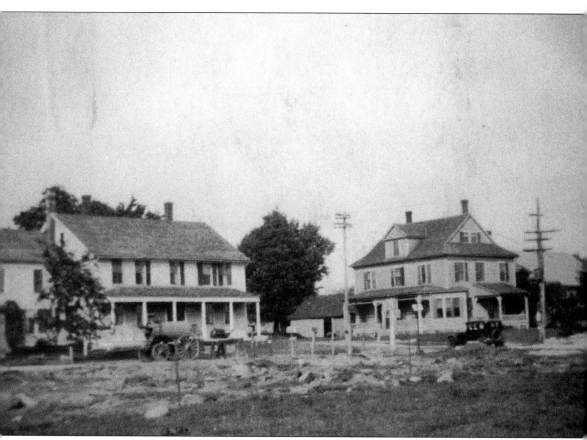

Few people realize that Shrewsbury once had another center of social and economic life—the little village of South Shrewsbury. In its heyday, South Shrewsbury was considered somewhat of a separate entity from the rest of the town, with old maps showing it in detail. The village had its start when Thomas Harrington settled in the area *c.* 1737. It grew slowly until the Boston and Worcester Turnpike opened in 1807, followed in 1809 by the opening of the Harrington Tavern at the corner of the turnpike and Grafton Street. The Harrington Tavern became one of the main features of the little village, growing over the years to include a large barn, dance hall, and several outbuildings. The tavern was very busy and several community dances were held in the hall each year. A small store was kept in the tavern building, but it soon outgrew its home and was moved to a separate building on the opposite side of Grafton Street. As the years passed, the town grew until the little village of South Shrewsbury had been forgotten. Except for a few old houses, all of its buildings are gone.

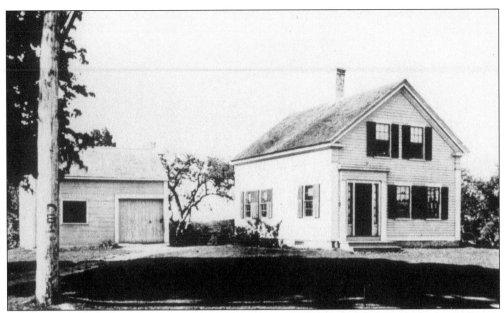

Levi Hemenway was a well-known Shrewsbury gunsmith. He built this house, which stood next to the South Common in South Shrewsbury. The small building was his gun shop. Hemenway prospered during the Civil War years, when it is said he lent money to the government, making a nice profit. Later, this was the home of Gardy Tuck. Still later, the Holden family lived here and sometimes boarded teachers from the No. 7 School nearby. The gun shop and house were torn down in 1964.

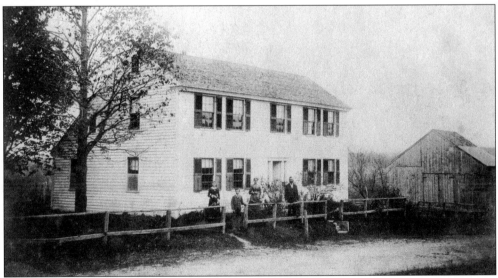

When Thomas Harrington built this house in 1737, he had no way of knowing that the area around it would someday become almost a separate little town from Shrewsbury Center. When the Boston and Worcester Turnpike opened, this area began to develop into what would become South Shrewsbury. The small village of South Shrewsbury existed until the growing town overtook it. The house itself was bought by the Winchester family in 1881 and is one of the few remaining from the days when everyone knew where South Shrewsbury was. (Courtesy Lucy Ward.)

The Causeway, or Dry Bridge, was part of the Boston and Worcester Turnpike where it passed through South Shrewsbury. It was built over a stream that ran parallel to Grafton Street. Shown here is Raymond Fletcher, a well-known attorney who met a tragic end when the horse pulling his carriage ran wild. The carriage overturned and Fletcher was thrown off and killed. The Causeway was covered over when Route 9 was built in the early 1930s.

During the 1950s and 1960s, Shrewsbury golfers had an 18-hole golf course to play on. Little St. Andrews was located at the southwest corner of Route 9 and South Street, near the Moors nightclub. Although it was less than full sized, the golf course still had several rules for golfers: "no high heels," "replace divots," "for tee shot use iron on the tee and thereafter use your putter," and, most importantly, "play and enjoy." The Little St. Andrews course closed in the mid-1960s.

SOCIAL DANCE

AT

Harrington's Hall,

South Shrewsbury,

WEDNESDAY EVENING,

JANUARY 2, 1878.

Your Company with Ladies is respectfully
solicited.

MANAGER:

ELI HARRINGTON,

Floor Managers:

H. T. HARRINGTON. D. H. KNOWLTON.

MUSIC:

Richardsons Orchestra

THREE PIECES.

A. A. BICKNELL, Prompter.

Dancing Tickets, 50 Cents.

Pictured is a dance card from a dance held on January 2, 1878, at Harrington's Tavern hall in South Shrewsbury. It lists Eli Harrington as the manager along with H.T. Harrington and D.H. Knowlton as floor managers. Richardson's three-piece orchestra provided the music and A.A. Bicknell was employed as a "prompter." The cost was 50¢ for a dance ticket. The reverse of the card listed the order of dances, which included such dances as the Lady Walpole Reel, Fisher's Hornpipe Waltz, and Money Musk Polka. Spaces were provided to write in the name of a dance partner for each dance.

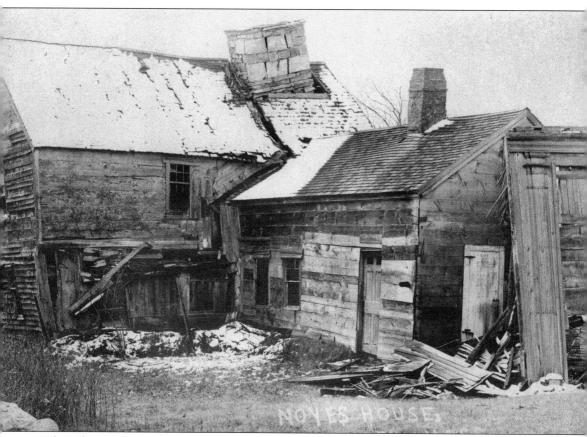

NOYES HOUSE.

When the porches were taken off the First Congregational Church in 1834, one of them was made into an addition to the old Noyes house. This house was located near the present-day intersection of Route 20 and South Street. It was very poorly maintained in its later years. It was known for its stone fireplace, which had alternating courses of large and small stones. One story tells that Mrs. Noyes used to smoke a pipe. Eventually, the house was gone and all that remained was the fireplace. The fireplace is now gone also.

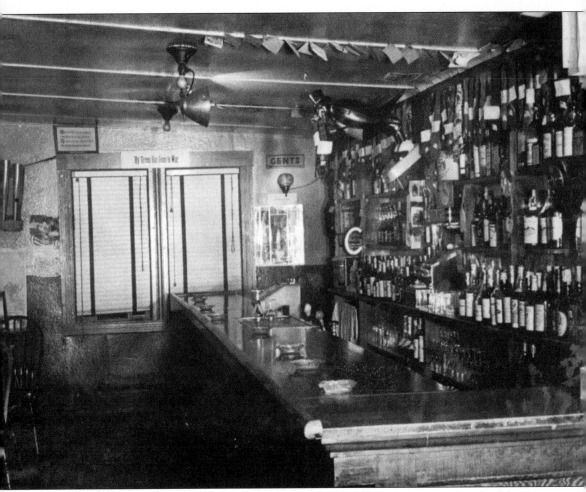

During the World War II years, Mickey Green's was a popular restaurant and nightclub. Here we see the bar area at Mickey Green's during this time. If you look closely, a number of neckties can be seen hanging behind and over the bar. It was a tradition during the war that when a young man went off to the service, his tie would be cut off and left behind at the bar to await his return. As the war progressed, the number of neckties, each with a paper tag identifying the owner, grew. When the war ended, most of the servicemen returned home and claimed their ties. There were too many, however, who never made it home. (Courtesy Donald Green.)

Billed as "Worcester County's first open-air auto theater," the theater that was later known as the Shrewsbury Drive-In opened in 1938. It was located at the corner of Fruit Street and the Boston Turnpike. The drive-in was intended to be an indoor-outdoor affair, but the Hurricane of 1938 ended thoughts of the inside movie theater. The Shrewsbury Drive-In enjoyed many years of prosperity but died out in the 1970s. The screen, concession stand, and sign lingered among abandoned speaker posts for a few more years, but the remnants were torn down in the early 1990s.

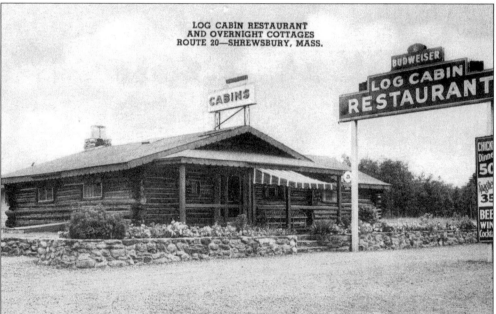

In the early 1930s, George Crooker took advantage of the growing number of trucks and automobiles passing through Shrewsbury on the newly constructed Routes 9 and 20. He built a restaurant, the Log Cabin, at the corner of Walnut Street and Route 20. The business prospered and was expanded to include nine overnight cabins. The Log Cabin changed owners several times but kept the same name. Finally, it was sold and remodeled, with the log exterior being covered and the name being changed.

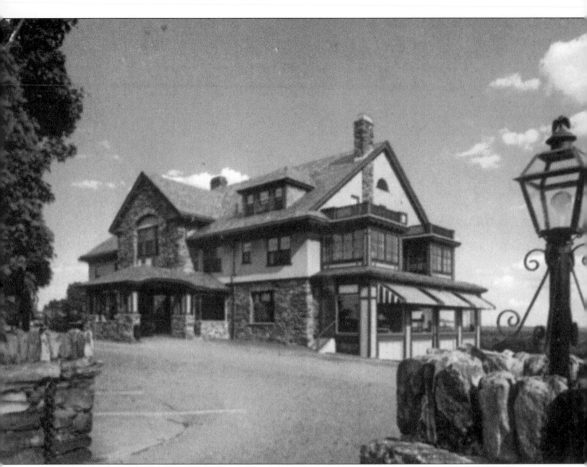

Edmund Hills built this beautiful Tudor stone mansion, known as Hillswold. Hills was president of the Providence Combing Mills, and Hillswold was used as his summer estate. The mansion itself contained 32 rooms and was considered one of the showplaces of Worcester County. The estate included a garage, barn, farmhouse, and dairy. The mansion was sold in 1927 for about $200,000. A plan to convert the estate into two 18-hole golf courses never materialized. In 1946, the estate was sold to Frederick Hebert, a candy maker who moved his business into the mansion. This was where the idea of a roadside candy shop was born. The business flourished and the Hebert's Candy Mansion became a landmark known far and wide.

In this photograph, young Katherine (Gualdi) Mero is shown cooling off in Jordan Pond on a hot summer's day in the early 1920s. Mero, who grew up and lived near Jordan Pond her entire life, passed away in 1998 at the age of 91. One of a number of icehouses that were in business at the pond can be seen in the background. The ramp was used to pull the ice up into the upper part of the icehouse for storage. A few years later, two of these buildings burned down in huge fires. (Courtesy Lucy Card.)

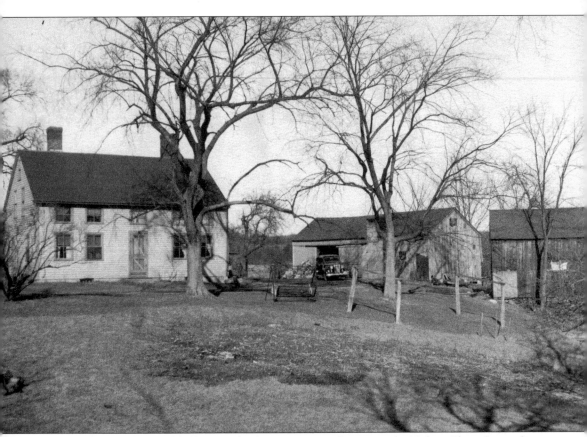

One of Shrewsbury's older houses, this home was once known as the Nelson Place. Jasper Stone Nelson built it in 1838. Nelson was the owner of a shoemaking business with locations in both North Grafton and Shrewsbury. His farm on Lake Street originally consisted of 200 acres. All the lumber used in this house was cut on the farm. Most of the lumber was hewn by hand. Slabs of granite were brought from Templeton on oxcarts and were used in the foundation. An old family story tells of the Indian Rock, located across the road in what used to be a pasture. This was a rock formation supposedly used by the Native Americans as a natural fireplace. Today, the farm has been sold off into house lots. The house itself remained in the same family from the time it was built until the 1990s.

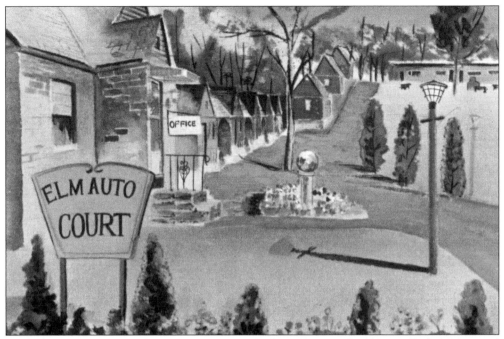

Shrewsbury's brand-new Elm Auto Court was built in 1957 at the corner of Elm Street and Route 9. Amenities included tile showers, central heating, televisions, and radios. An outdoor fireplace and picnic grounds were part of the premises. One family of travelers described the accommodations, consisting of 60 units: "This is our nicest one to date, everything brand new." The name of the property was changed to the Shrewsbury Motor Inn and still later to the Tudor Motor Inn. The business closed for good in the 1990s, and the buildings stood vacant for a number of years before being razed.

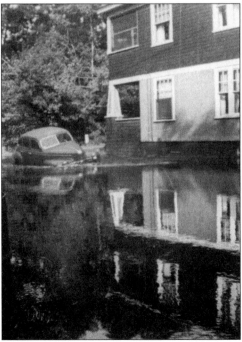

In August 1955, severe floods ravaged Worcester County. Many homes in Shrewsbury were affected, particularly when the dam at Old Mill Pond was overwhelmed by the rising water. The raging waters rushed downstream toward Lake Quinsigamond. In this view, we can see the result in the area around 64 North Quinsigamond Avenue, where the DiCicco family lived. The floodwaters in the rear of the house, where the land drops off, reached a depth of 14 feet. The DiCicco family had to be evacuated by the fire department. After five days, the flood receded and the neighborhood returned to normal. (Courtesy Paul DiCicco.)

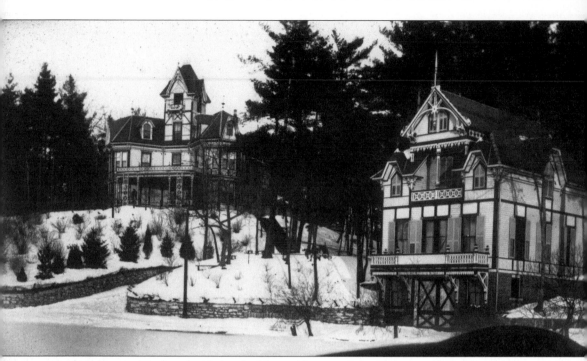

In 1878, Horace Bigelow decided to build a residence at Lake Quinsigamond. This was not to be just an ordinary home, but a showplace. The Bigelow Mansion, as it came to be known, was filled with antiques and boasted fine wood paneling. Mosaics adorned the walls and floors. This photograph, taken from the ice, shows the mansion and boathouse. In 1955, many years after Bigelow's death, the family sold the estate to the owners of the White City Amusement Park. The buildings were torn down or destroyed in a series of set fires. The mansion itself burned in a huge fire that attracted an estimated 4,000 onlookers. The site was later made into a parking area and is now covered by part of the White City Shopping Center. (Courtesy J. Ronald Bigelow.)

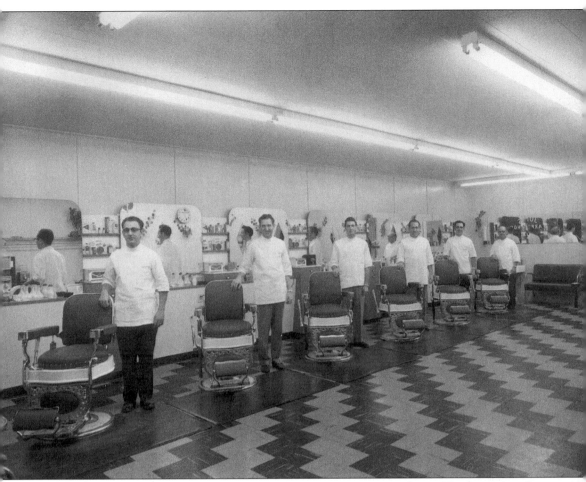

John Martellotta Sr. opened a barbershop in Shrewsbury in 1934. In this 1955 view, we see the six barbers at a newly remodeled John's Barber Shop. The barbershop was in the building at 166 Boston Turnpike, at the corner of Plainfield Avenue. The barbers are, from left to right, John Martellotta Jr., Frank Brunell, Tony Amato, Joe Lupisella, Cosmo Martellotta, and John Martellotta Sr. (Courtesy Sal Belsito.)

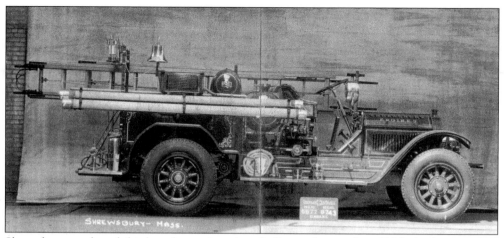

Shrewsbury purchased this brand-new American LaFrance fire truck in 1926. At the time, this "triple combination" was the latest in firefighting equipment, having a pump, water tank, and booster hose. This picture is the original delivery photograph from the American LaFrance factory in Elmira, New York, showing the truck fully outfitted. Chief Edward Logan accepted Engine No. 3, as it was designated, for use on July 23, 1926. The truck was somewhat underpowered—several retired firefighters remember being able to run up the Maple Avenue hill faster than the truck would go, at least until they got tired and jumped back on board. The town sold Engine No. 3 in the mid-1950s. (Courtesy Tim Treadway.)

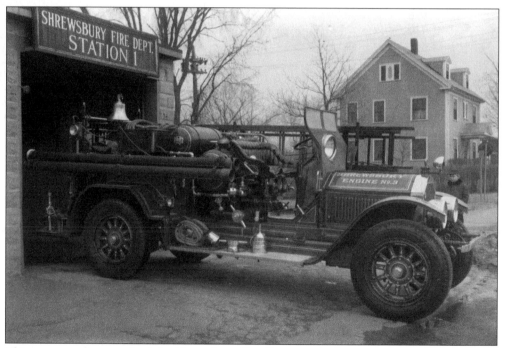

This is a rare photograph of the Shrewsbury Fire Station, which occupied the building at the corner of Dewey Road and Route 9. A fire company was formed at Lake Quinsigamond in 1916 and was housed in the Dufresne Brothers Laundry building. The company later moved to the location shown here. These quarters were used until the new fire station on Harrington Avenue was built in 1951.

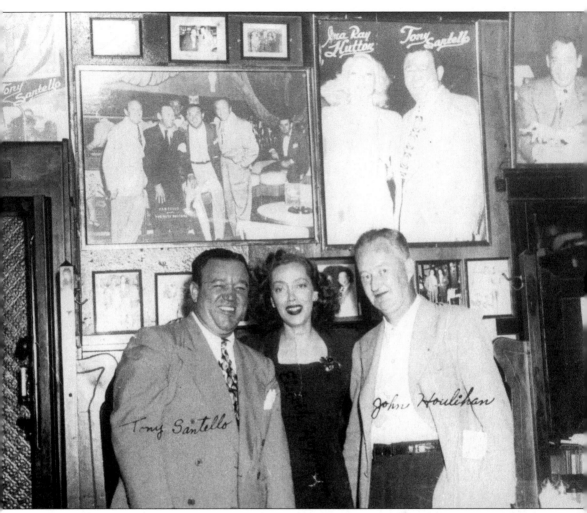

There were many nightclubs in the area near the White City Amusement Park. These included Tilli's, the Palais Royale, the Happy Hour, and Bronzo's. The Happy Hour stood at the corner of North Quinsigamond Avenue and Route 9. It was a well-known stopping place for celebrities. Some of the more spectacular guests included Jane Russell, Milton Berle, Jack Benny, Frank Sinatra, Cab Calloway, Dagmar, and Danny Kaye. Photographs of many of these famous visitors, along with the proprietor, Tony "Champ" Santello, lined the walls of the Happy Hour. Here we see Santello posing with two guests in front of some of these photographs. A colorful character who was once a boxer, the Champ liked to sit neighborhood kids on the bar and give them a soda and a $2 bill. This was quite a large sum of money in those days. (Courtesy Paul DiCicco.)

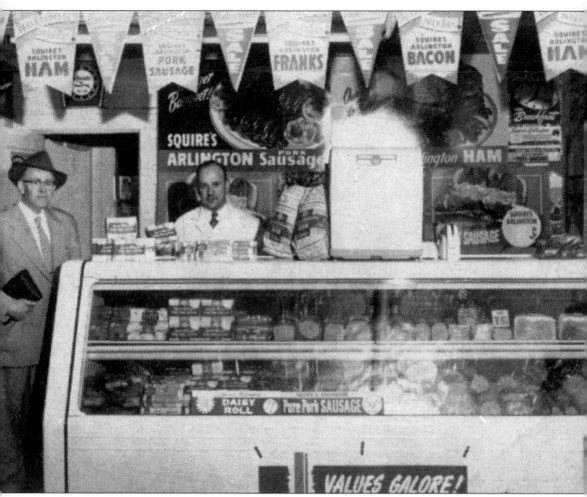

A business that would become a Shrewsbury tradition was born in a small Route 9 office in 1924. At that time, Orlando Orrizzi was operating a small trucking company out of a 14-by-14-foot office at the corner of Edgewater Avenue and the Boston and Worcester Turnpike. Within a few years, a larger building was erected next door that incorporated a market on the first floor with living quarters for the Orrizzi family on the second floor. The Lake Junction market prospered over the next three decades, with the name eventually being changed to Orlando's Market. Orlando's three sons—Hugo, Guido, and Orlando Jr.—later took over operation of the store. In this photograph, Hugo is shown at the meat counter in 1952. In 1953, a brand-new market was opened just to the east of the old store. This modern facility would serve as a mainstay of the grocery business in Shrewsbury until it closed in 1982, more than 50 years from when the business started. (Courtesy Hugo Orrizzi.)

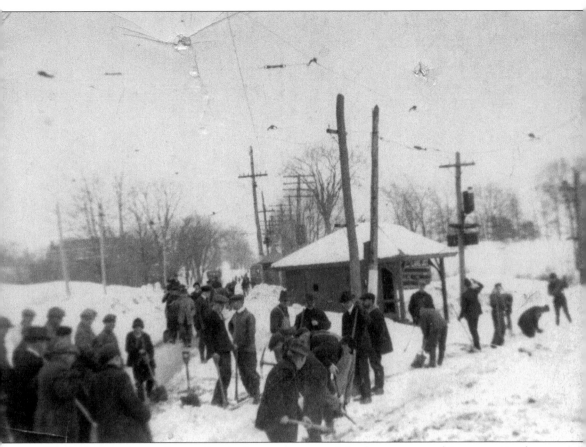

The Lake Junction trolley station is shown after one of the huge snow and ice storms in the 1920s. The view shows neighborhood men and boys, hired by the trolley companies, clearing the snow and ice from the tracks so the trolleys could run. One of the trolleys traveling on the turnpike can just be made out to the left of the small passenger platform. Lake Junction was located directly opposite from where Spag's Supply is today. A manually operated switch changed the direction of the tracks at this point. Some trolley conductors tossed pennies to the neighborhood boys if they flipped the switch for them, although one conductor refused to part with his coins and earned the wrath of the boys. Lake Junction ceased to exist when the trolley lines closed down. The thousands of people who travel busy Route 9 today have no idea it was ever there.

The Evolution
of the
Motor Car, in Pictures

Although very few people realize it today, Shrewsbury once was the home of an antique automobile museum. The Museum of Transportation was located near the corner of Route 9 and South Quinsigamond Avenue in a large brick building. The Garganigo family started the museum, which became a popular attraction for visitors to the nearby White City Amusement Park. The museum's collection grew larger through the 1930s. In 1938, it was decided to move the museum to Princeton, Massachusetts, where it was in operation until the 1960s. When the museum closed, the collection of antique automobiles was sold. The booklet shown here was published in 1933 and included photographs of many of the ancient vehicles in the collection.

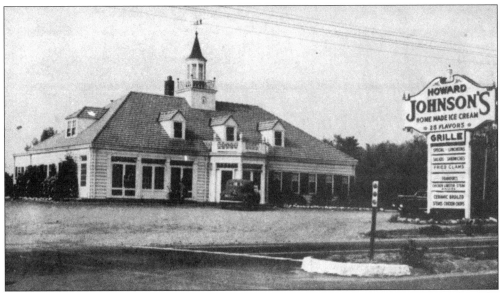

Howard Johnson's was opened on Route 9 at the corner of Harrington Avenue in 1938. The restaurant with the orange roof, along with many like it throughout the country, featured 28 flavors of homemade ice cream along with chicken, broiled steak, and chops. In the 1970s, the Squires Lounge was added to the operation. Later still, Howard Johnson's was replaced with the Ground Round.

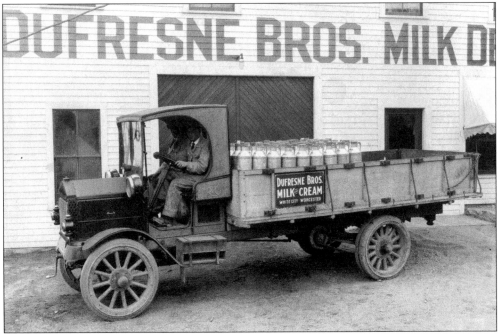

The Dufresne family had a number of businesses in the area on the north side of the Lake Quinsigamond Bridge. The Dufresne Brothers Dairy is shown in this view, along with one of their delivery trucks. The truck had replaced horse-drawn delivery wagons. Modern-day scuba divers still find milk bottles with the imprint "Dufresne Brothers Shrewsbury" in the depths of the nearby lake.

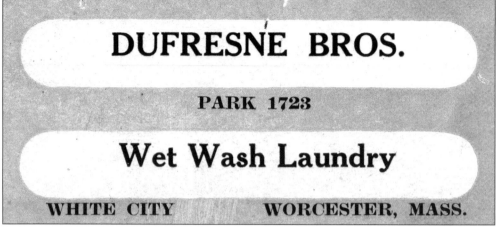

DUFRESNE BROS.

PARK 1723

Wet Wash Laundry

WHITE CITY **WORCESTER, MASS.**

Two other businesses operated by the Dufresne's were the Dufresne Brothers Wet Wash Laundry and the Lake Shore Market. Above is an advertising blotter from the laundry business, and below is the market. When the Lake Shore Market went out of business, the name was picked up by Joseph Leblanc, whose market operated at the corner of South Quinsigamond Avenue and Ridgeland Road until 2000.

Five

WHITE CITY, EDGEMERE, AND THE LAKE

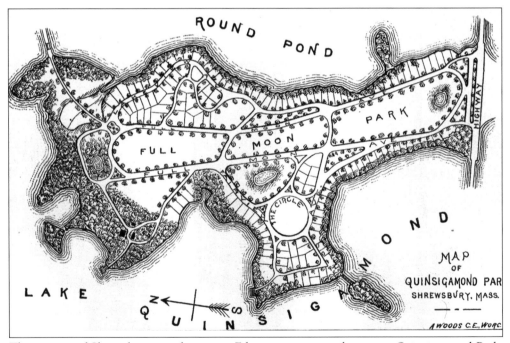

The section of Shrewsbury now known as Edgemere was once known as Quinsigamond Park. In 1886, Horace H. Bigelow purchased much of this area, about 100 acres. He developed the picnic groves and an old horse-racing track into private house lots. An account published in 1888 describes his efforts: "Trees have been set out, streets opened, drives completed, the old grove and grounds improved and repaired. All looks ready for the arrival of the village with its cottages, gardens, flowers, children and schools." Bigelow's vision of a little village of homes came true and Edgemere became just such a neighborhood.

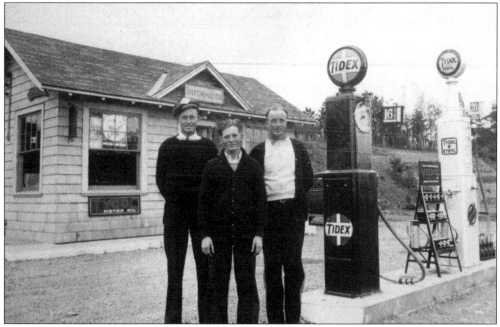

The Tidex filling station was located at the intersection of Edgemere Boulevard and the Hartford Pike. The little station received a great boost in business when Route 20 was built, finding itself on a major highway between Boston and New York. Two members of the Ljunggren family are shown standing on the left and the right. The price of gasoline at this time was a whopping $16^3/_{10}$¢ per gallon. (Courtesy Robert and Brenda Ljunggren.)

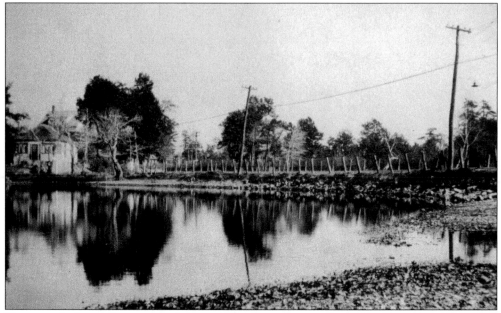

This view looks southeast toward the road that later became Route 20. The intersection with Edgemere Boulevard is just out of sight on the left. The road was much lower at this time and had a fence installed to keep people from driving off the road into Half Moon Cove. (Courtesy Robert and Brenda Ljunggren.)

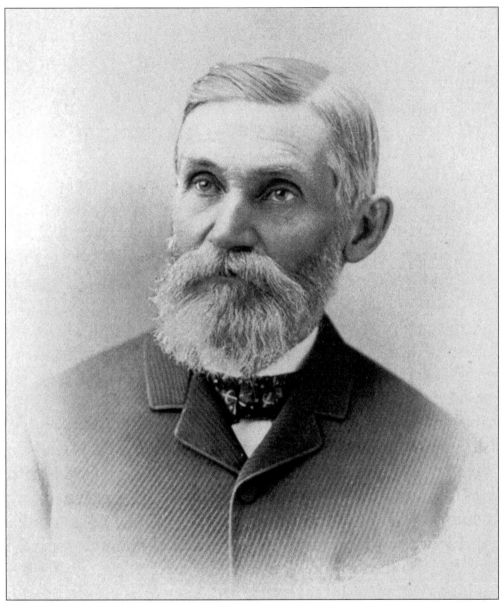

The name of Horace H. Bigelow is one that few local people would recognize today. This was not the case c. 1900. Bigelow was a wealthy industrialist who had made his fortune in the shoemaking industry, inventing, and real estate. In his later years, Bigelow turned to other pursuits. He began to develop property around Lake Quinsigamond. He owned the land at the corner of Route 9 and South Quinsigamond Avenue, which he called Quinsigamond Forest. Along with a Mr. Davis, he gave land to the city of Worcester that was made into Lake Park. He became involved in running steamboats on the lake and operation of the Worcester and Shrewsbury Railroad, which ran from Union Station to Lake Quinsigamond. He also bought up large tracts of land in Edgemere, where a picnic grove, hotel, and horse-racing track were located. It was not until 1905 that the crown jewel of Bigelow's lake developments was built— the White City Amusement Park. Bigelow died in 1911, only six years after the White City Amusement Park opened.

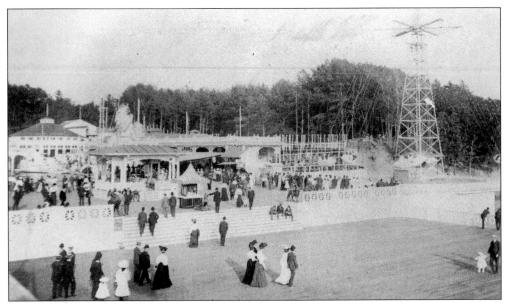

When it opened in 1905, the White City Amusement Park was immediately a huge success. Everyone asks where the White City Amusement Park got its name. It was named after a popular exhibit at the Colombian Exposition in 1895. At that time, the electric light bulb was still somewhat of a novelty. When the park opened, it was advertised as having "50,000 electric lights." Although the number of bulbs was probably inflated, the effect of many white lights reflected by the white paint used on park buildings must have been impressive in 1905.

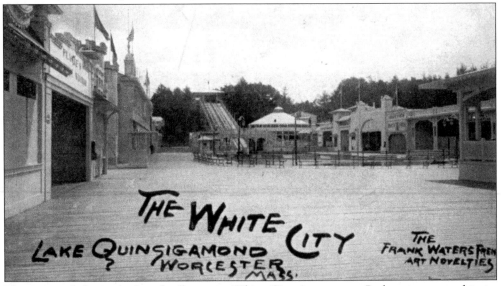

This postcard shows the boardwalk area at White City Amusement Park as it appeared in its early years. The boardwalk surrounded the man-made pool that was used for the Shoot the Chutes ride. This pool and the ramp-shaped structure used for the chutes can be seen in the center background of this view. Just to the right of the ramp is the building that housed the famous White City Amusement Park carousel. The buildings to the left and right housed various attractions and games of chance. The White City Bandstand is partially visible at the far right.

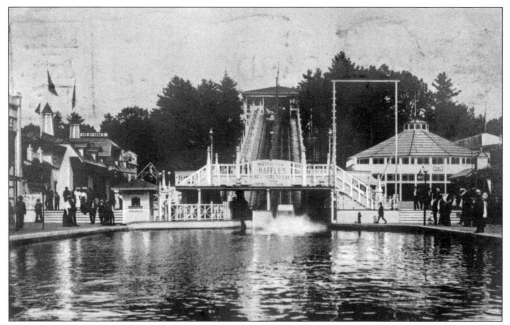

The Shoot the Chutes was the centerpiece of the White City Amusement Park. The ride is shown shortly after the park opened in 1905. Flat-bottomed boats full of people would roar down the chutes until hitting the surface of a man-made pond with a huge splash. This ride was a predecessor of the log flume rides that exist at many amusement parks today. The Shoot the Chutes was removed in the 1920s, and the pond was made into a swimming pool.

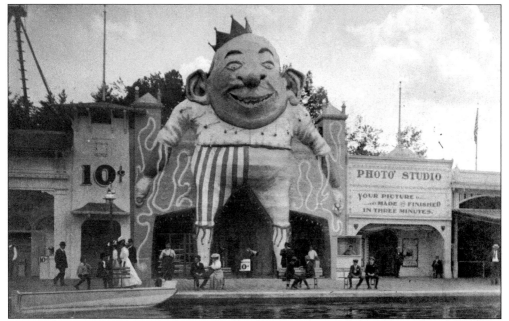

King Dodo's Palace was one of the main attractions when the spectacular White City Amusement Park opened in 1905. This was an early version of a fun house. King Dodo stood watch over the park until a major renovation took place in the 1920s. The booth on the right would produce an early version of an instant photograph—quite a novelty for its time.

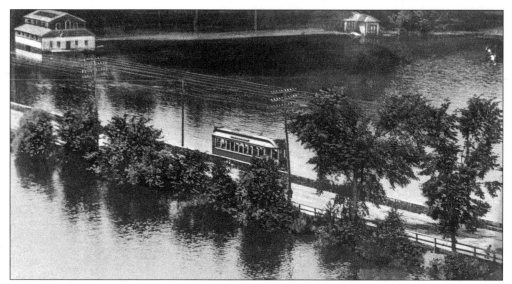

When the Boston and Worcester Turnpike was built in the early 1800s, the road spanned Lake Quinsigamond on a floating bridge. The bridge was located in the same place as where the Route 9 bridge stands today. A few years later, a plan to build a bridge on wooden piers ended in a complete failure, when the lumber used in construction proved to be too buoyant. Another floating bridge was then put in place. During the Civil War, it was decided to replace the floating bridge system with a dirt causeway. Later on, the trolleys, as seen here, traveled along the north side of the causeway. The causeway was replaced when a concrete bridge was built on the site after World War I.

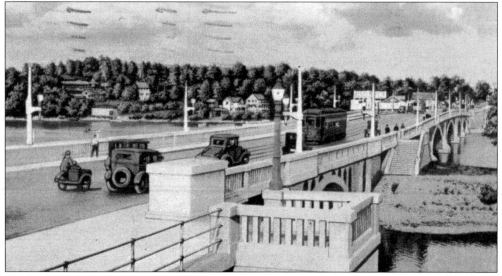

By the 1890s, people wanted a more modern way to cross Lake Quinsigamond. This would replace the old dirt causeway built during the Civil War. People argued for years over the length, width, materials, height, and general design of the proposed bridge. This continued for almost 30 years until an agreement was finally reached. Construction was started in 1916 and was finished in 1919. When the new concrete bridge was dedicated on July 31, 1919, an audience estimated at 25,000 crowded the area, both on land and afloat. The bridge was modernized in the early 1980s and is still in service.

By 1870, regattas had become a popular event at Lake Quinsigamond. That year, a grand Promenade Concert and Dance was held at Mechanics Hall the night before the race. The affair was well attended by the college and boat club crews alike, and also by the elite of Worcester society. Everyone in attendance had a wonderful time, judging from newspaper reports of the day. The scene the next day was not quite as pleasant, however. The regatta was marred by claims and counterclaims of fouls during the races. Harvard, Yale, Brown, and Amherst all challenged their opponents. The judges reserved their opinions until the next day, resulting in the police being posted at the Bay State House hotel to prevent any trouble between the crew teams staying there. The next day, Harvard and Amherst were declared the winners. Here, photographer E. Berg captures the Amherst crew. Two of the men are wearing ribbons, perhaps earned for their victory over the Brown crew.

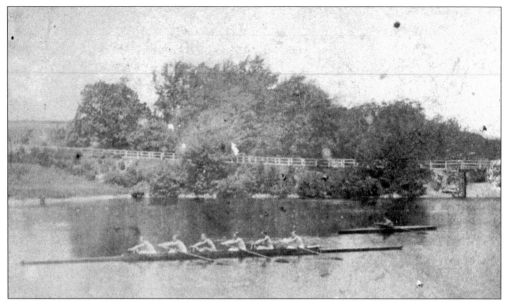

By 1879, crew racing was a well-established annual event on Lake Quinsigamond. The first races had been held in the late 1850s, with a great rivalry between Harvard and Yale quickly developing. The races have continued, with some intermittent periods, right up to the large-scale Eastern Sprints held on the lake today. In this early photograph from a stereopticon card, we see the crew from Amherst preparing for a race. The view was taken looking north toward the causeway, which once spanned the lake where the Route 9 bridge stands today. The boat is headed for the opening that allowed access to the racecourse on the north end of the lake, right where the races are still held.

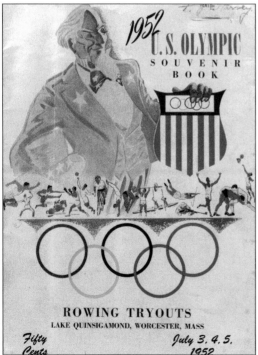

During the first week of July 1952, Lake Quinsigamond was the site of the Olympic Rowing Tryouts for the 15th Olympiad. These Olympic Games were held in Helsinki, Finland. The program shown here contained a great deal of background on the 1948 games, plus a number of articles describing how the rowing tryouts came to be held at Lake Quinsigamond. The many advertisements for local businesses make interesting reading today, as most are now long gone.

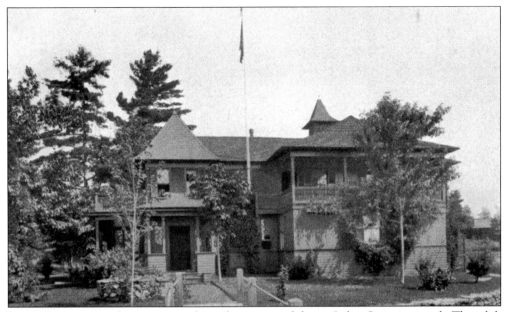

In 1889, a group of young men formed a canoe club on Lake Quinsigamond. The club purchased a 12-man "war canoe" in which they cruised the lake, and the members wore distinctive uniforms of white, black, and orange with a "sunflower totem" logo on the breast. The Tatassits decided to build a clubhouse on Plum Island, shown here. Completed in 1891, the building was added onto over the years. By the 1920s, interest began to wane and, in 1928, the property was sold and became the Tatassit Bathing Beach.

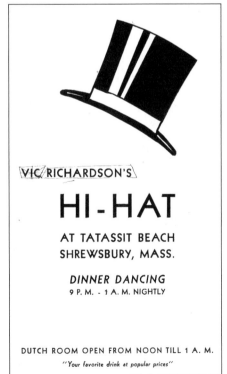

The Hi-Hat was a nightclub located in the old Tatassit Canoe Club building on little Plum Island, just off shore from Tatassit Beach on South Quinsigamond Avenue. The club had a restaurant, dance floor, and bar. The place was done up in a 42nd Street theme, with murals painted on the walls. As people would cross the little footbridge over to the island, a tall man in a black cape and top hat would bow and say, "Welcome to the Hi-Hat." The nightclub closed in the early 1940s, and the building was transformed into summer rentals. The building still stands today, although in very poor repair.

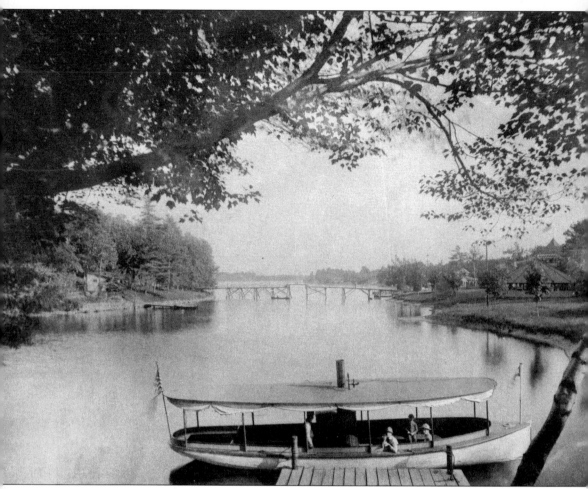

Attempts to run steamboats on Lake Quinsigamond began as early as 1847, but they were not generally successful until the years following the Civil War. J.J. Coburn, a great developer of the lake region, put the *Phil Sheridan* into service just after the war. By 1873, a man named S.E. Harthan had two boats in operation, a small steam launch named the *Little Favorite* and a much larger and well-furnished side-wheeler named the *Addie*. Business was good and, by 1877, the *Little Favorite* was sold to a private party and replaced by the larger *Zephyr*. The number of steamboats grew until there was a large variety of shapes and sizes in use. Steamboat docks and landings were located at almost all the places of interest around the lake. This photograph may be of the *Zephyr*, although it has not been positively identified. The view is looking south from the causeway, with the hotel on Ramshorn Island to the left and Lincoln Park to the right. The steamboats were eventually doomed by the introduction of the outboard motor.

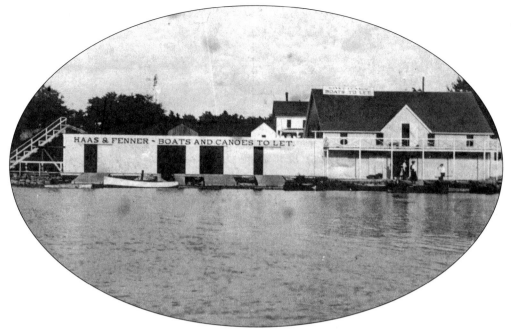

The Haas & Fenner Boat House was one of many that once lined the shores of Lake Quinsigamond. This building stood at the northeast corner of the Route 9 bridge. This business later became the Fenner Boat House. It eventually went out of business, and the building is no longer standing. (Courtesy Nicholas Perrone.)

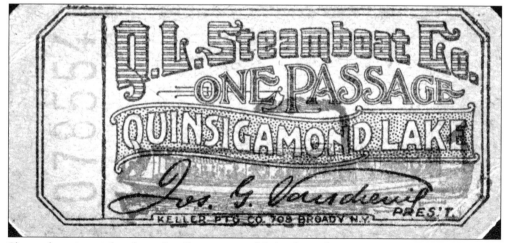

Shown here is a ticket from the Quinsigamond Lake Steamboat Company. On it is a banner reading "Quinsigamond Lake" over a drawing of a steamboat. It also has a facsimile signature of Joseph G. Vaudreuil, president of the line at the time.

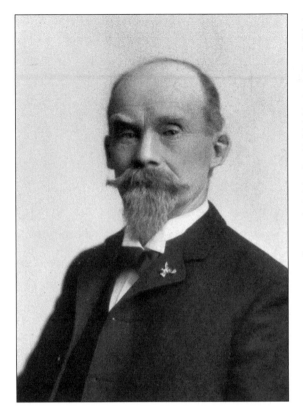

Joseph Godfroi Vaudreuil was a Canadian immigrant who came to Worcester in 1868. He became a very successful contractor, known for being the builder of many fine homes, including the Moen mansion in Shrewsbury. He built himself a fine home on Lake Quinsigamond in the Edgemere section of Shrewsbury, the Villa Vaudreuil. He was known as "the Commodore" of the lake and was president of the Quinsigamond Steamboat Company. He was often found wearing a blue yachtsman's cap and blazer in his frequent trips on the lake. He was also a member of the Tatassit Canoe Club. J.G. Vaudreuil passed away at the age of 55 in 1905.

Back in Lake Quinsigamond's heyday, there were few homes around its shores that could have been described as elaborate. There were a few exceptions, one being the Villa Vaudreuil, the summer residence of Joseph G. Vaudreuil. It stood at the water's edge on what was then known as Folly Cove, in the Edgemere section of Shrewsbury. The home remained in the family for many years. Starting in 1917, it was operated as a lodge, first by Vaudreuil's son and then by his widow until finally being sold. The Villa Vaudreuil burned in 1968.

From 1940 into the 1960s, Walfred and Martha Sundman ran a busy boathouse in the Edgemere section of Shrewsbury, located just north of the bridge over Route 20 where Lake Quinsigamond enters Flagg Pond. Walfred Sundman built all of his boats himself, sometimes working long into the night. The boathouse was more than just a boat rental business. The Sundmans' sold bait and tackle and operated a snack bar where they sold candy, soda, ice cream, and potato chips. The boats were rented for 50¢ an hour. The business lasted into the 1960s, with the boathouse being torn down in 1994. (Courtesy Betty [Sundman] Marcimo.)

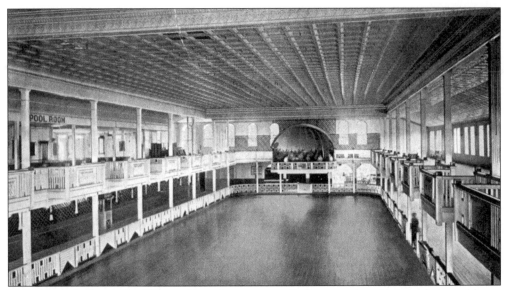

The dance hall at the White City Amusement Park was advertised as being able to accommodate 1,000 people on the dance floor. In reality, that was probably exaggerated, although it was still an impressive facility. The dance hall was very popular throughout the many years the White City Amusement Park was in operation. It did change names, being known at one point as Danny Duggan's Deck and at another time as the Spanish Villa. It was well known as a home to dance marathons, when those were the rage. Many area couples met and danced the night away at the White City Amusement Park dance hall.

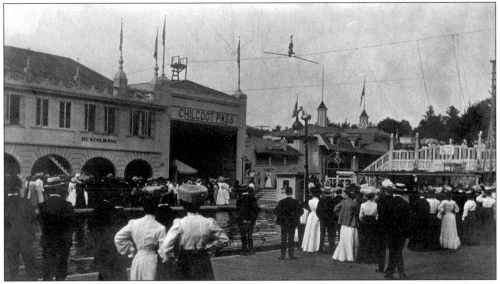

When the White City Amusement Park was in its prime, free performances were held each week to help draw in the crowds. All kinds of acts appeared, such as diving girls and horses, bands, tame bears, and wild animal acts. One of the most exciting acts was the high wire artists. Here, Madamoiselle Luelita performs high above the crowd. She appeared in July 1905, shortly after the White City Amusement Park opened in June of that year. These performances continued well into the 1950s, with several well-known singing groups appearing on the stage at the park.

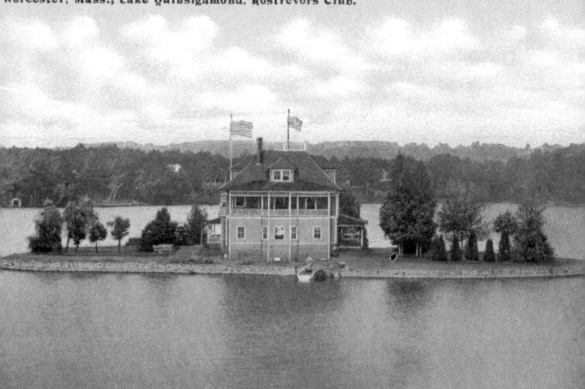

In the 1880s, the Rostrevors Club was one of a large collection of social and ethnic clubs around Lake Quinsigamond. This particular club was located on what became known as Rostrevors Island at the southern end of the lake. It was a French social club, one of several which included the Frontenac and Progress Clubs. The Rostrevors was very popular and had many social affairs in its day. The club was one of many that participated in the yearly "opening of the clubs" each summer. This was a huge "open house" at clubs up and down the lake, with visitors welcome. The Rostrevors Club building is no longer standing.

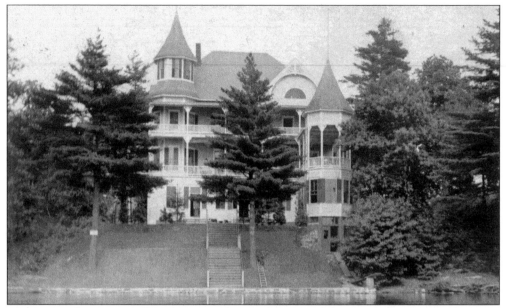

The Svea Gille was one of the largest and most elaborate of the many ethnic clubs that once stood on the shores of Lake Quinsigamond. Built in 1894, the Svea Gille served as a meeting place for the area's Swedish population. It stood on South Quinsigamond Avenue, just opposite Oak Street. The building was torn down in 1987 and a condominium complex now occupies this property.

In 1888, a committee was formed for the express purpose of giving names to points around Lake Quinsigamond. The committee itself was made up of several distinguished Worcester-area citizens. One of the features named by the group was the Sanctuary, an inlet on the northeastern shore of the lake. Over the years, the Sanctuary became a well-known spot for canoeists to take their lady friends "spooning" on a weekend afternoon. Over the years, parts of the inlet were filled in or clogged by weeds. Today, what remains of the Sanctuary still runs under North Quinsigamond Avenue behind the buildings located on Eaglehead Terrace.

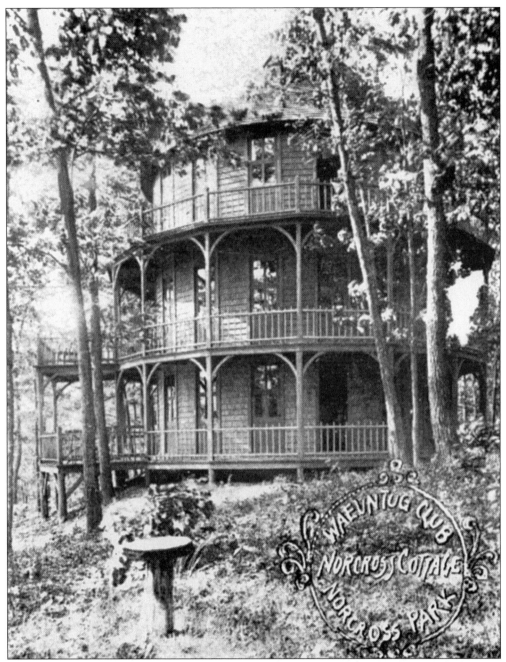

As can be seen in this turn-of-the-century view, the Waeuntug Club building was unique. In an account from 1886, it was described as "the odd little building, which the frequenters of the Lake call the 'oil can' because it is quite round and is topped off by a slanting roof, with a chimney in the center to carry out the resemblance." The club was located on Lake Quinsigamond, near what is now 115 South Quinsigamond Avenue. After dark, a row of torches lined the waterfront, along with Chinese lanterns that lit up the grounds, creating a beautiful display. The club itself was small, having four officers and eleven members in 1886. The building and club no longer exist.

Sometime around 1888, the *Gesang Verein Frohsinn*, or Frohsinn Club, decided to obtain summer quarters on Lake Quinsigamond. They built a handsome clubhouse located in Shrewsbury, just north of the causeway across the lake. Club members enjoyed the accommodations throughout many summers. By 1915, the group gave up its downtown Worcester quarters and used the clubhouse at the lake exclusively. Unfortunately, catastrophe struck the club in March 1936, when a fire burned the building down. A new clubhouse was built and is still in use today.

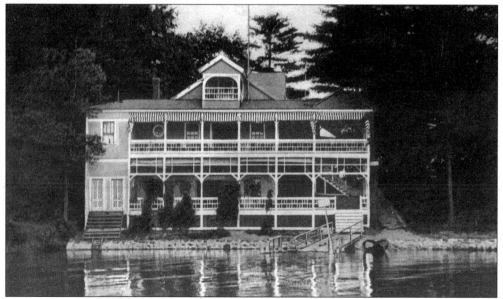

The *Turn Verein*, or Turner's Club, was one of the first of the many social and ethnic clubs built at Lake Quinsigamond in the years after the Civil War. Its members were of German descent and were known for their abilities as gymnasts. The building was later home to a combination restaurant and ice-cream parlor known as Groezingers. In 1940, the Lakemen's Lodge bought the building. After World War II, it was sold to the Lithuanian War Veterans organization.

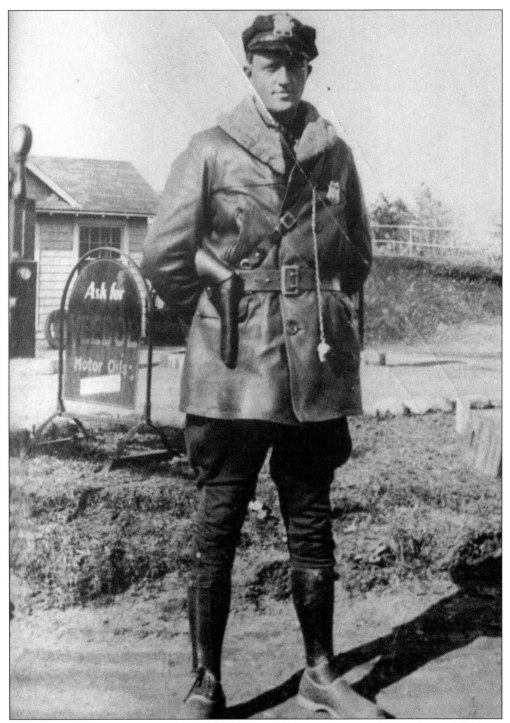

Ivar Ljunggren was a longtime Edgemere resident. He is seen here *c.* 1930 in front of the little gas station at the corner of Edgemere Boulevard and what was soon to become Route 20. Ljunggren, a special police officer for the town. Here is is in full uniform, complete from head to toe, including his whistle. (Courtesy Robert and Brenda Ljunggren.)

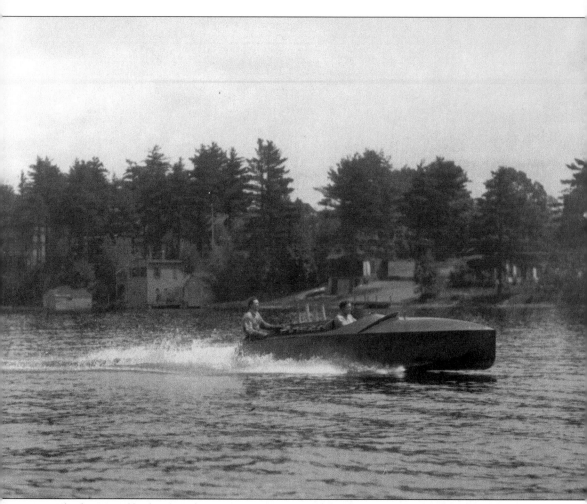

The history of hydroplane boat racing on Lake Quinsigamond takes us back to the years when motorboats were a fairly new innovation. The races became popular in the times after World War I and continued to attract large crowds throughout the 1920s. In this 1919 photograph, we see what is described as one of the first hydroplane boats speeding along the surface of the lake. Roscoe G. Bicknell and a Mr. Duby made the boat. Bicknell is shown here driving the boat with Mr. Duby as a passenger. (Courtesy Roscoe Bicknell.)

Whether it rained or shined, many participants remembered one part of opening day of fishing season best. This was when the fishing derbies were held at many local locations. At Coolidge School, students would sell buttons in different sizes in order to raise funds to buy prizes for the Sunrise Trout Derby. Started in 1947 by Lester "Pop" Dyer, this derby featured all kinds of prizes, with the grand prize being two brand-new bicycles, one each for the boy and girl catching the largest trout. The last opening day was held in 1972.

CALVIN COOLIDGE SCHOOL
SUNRISE TROUT DERBY
1961
SHREWSBURY, MASS.

This view was taken on the opening day of the 1952 fishing season. Dolores (Perna) Qualey and her cousin arose at 4 A.M. Her cousin slept with his watch, just to make sure his aunt would not let them sleep past the prime fishing hours. Off they went to the lake in search of the big one. As the 10 A.M. deadline for the Coolidge School Sunrise Fishing Derby approached, there was nary a fish in sight. Suddenly, Dolores landed a good-sized trout. Her cousin, being somewhat miffed at being outdone by an amateur, would not help her take the fish off the hook. In order to beat the deadline and secure a prize, Dolores ran all the way to the school with the fish still dangling from the line, just in time to get a prize.

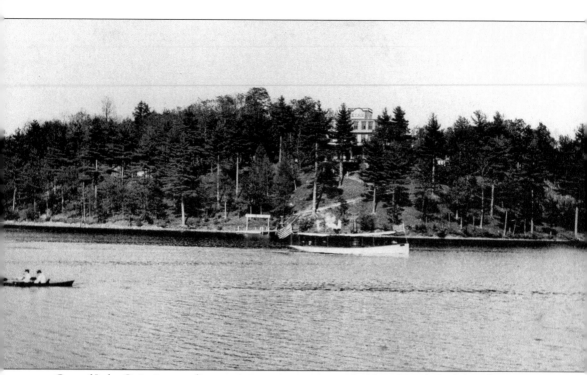

One of Lake Quinsigamond's most interesting spots was the Eyrie Hotel. Built by Thomas Rice in 1875 on a high bluff, its grounds were laid out with scenic walks, beds of flowers, two ponds (one with a fountain, the other for ducks), and a gaily painted windmill used to pump water up from the lake. Just south of the hotel was a raised pavilion, below which was located the Eyrie's namesake, a live eagle that devoured 6 to 10 large fish a day. Other walks led down to a steamboat landing, shown in this view with a steamboat that is probably headed for the Eyrie Gardens, located slightly to the south. The hotel was immensely popular. By 1877, it was noted that on some days 300 carriages would visit. The original hotel burned in 1878. It was replaced by a larger, more elaborate structure that survived until more modern times. It later became Olympia Park, a popular dance hall in the 1930s and 1940s that burned down in the 1970s.

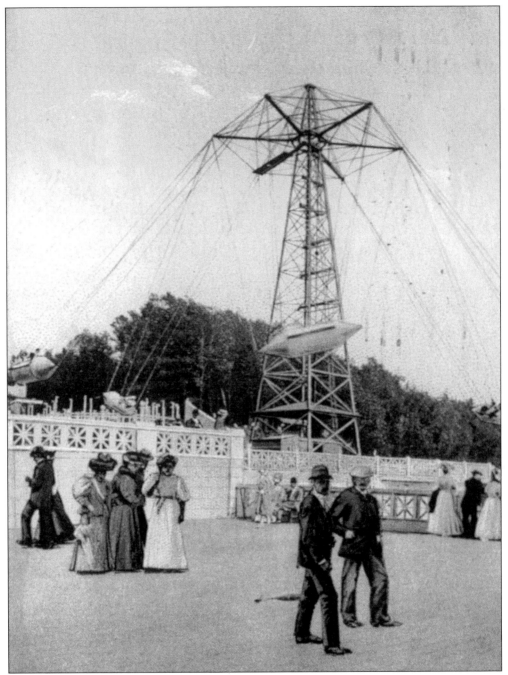

One of the longest-lasting attractions at the White City Amusement Park was what was originally known as the Circle Swings. Described in some advertisements as the "Whirl of Captive Airships" ride, the attraction is shown during the White City Amusement Park's first year of operation in 1905. The ride would be updated through the years, until finally the airships were gleaming-chrome rockets. These had pointy noses and rocket exhaust pipes in the rear, just the way real rocket ships did—quite unlike these earlier versions, which were pointy on both ends. This ride lasted until the park closed in 1960.

SPORTS PALACE ARCADE
Skee-Ball & Pokerino
White City Park, Mass.

ONE COUPON

Coupons redeemable anytime during season issued

SAVE COUPONS FOR LARGER PRIZES

GLOBE TICKET COMPANY—BOSTON

Games found at the White City Amusement Park included Skee Ball, Pokerino, and pinball machines. This coupon could be redeemed for prizes at the Sports Palace Arcade. At the time, many towns and cities had banned pinball games, feeling that they promoted gambling. The Shrewsbury Board of Selectmen granted a license for the pinball games and other coin-operated machines in the arcade after receiving assurances from the park's operators that no gambling would take place. The games stayed, with little or no adverse effects on the town's inhabitants.

There are more than a dozen islands in Lake Quinsigamond. Through the years, most of these have had their names changed at least once. For instance, the lake's northernmost island has had at least two names—White Pine Island and Camp Island. The first name was for the tall pine trees that grew on the little island. The second name came about after the summer camp shown here was built on the spot. Even after the camp no longer existed, the name stuck. Many postcard views show the little island, without any structures standing at all, and are titled "Camp Island, Lake Quinsigamond." People traveling over the Lincoln Street Bridge can see this same view, although the island is now heavily wooded.

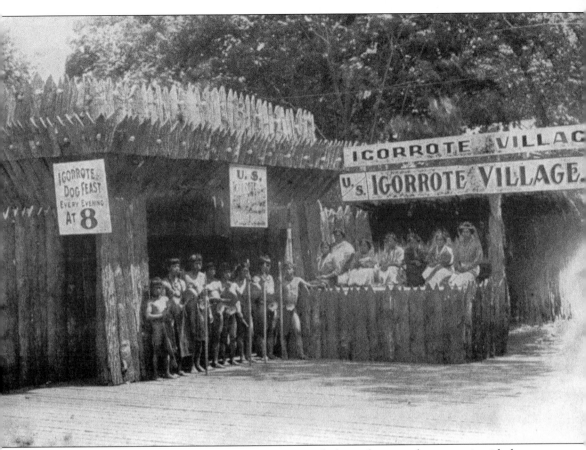

What would an early-20th-century amusement park have been without exotic sideshow attractions? The White City Amusement Park was equipped with a wide variety of these in its early years. One of interest was the U.S. Igorrote Village. The Igorrotes were natives of the Philippine Islands, which had only been under U.S. control for a few years in 1907. Here the Igorrotes pose in their somewhat scanty native dress. One of the signs advertises an "Igorrote Dog Feast Every Evening at 8." Whether or not any local canines were served up is doubtful, but the fact remains that the tribe members were uprooted from their homes to visit Shrewsbury. We can say with some certainty that Shrewsbury has not since seen anything quite like the Igorrotes' visit.

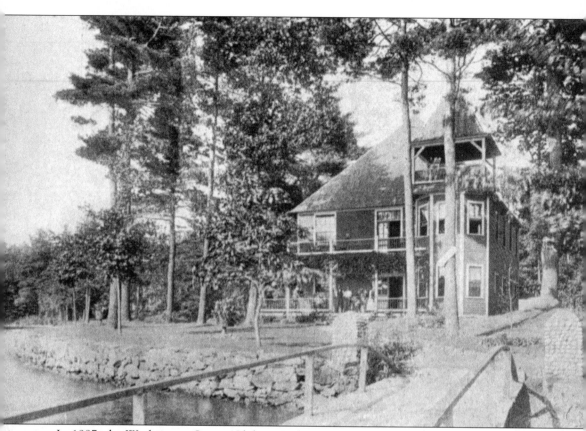

In 1887, the Washington Square Club, or Irish Catholic Professional Men's Club (a group of men of Irish descent), built a well-appointed clubhouse on Lake Quinsigamond. This building was located at what is now 142 South Quinsigamond Avenue and was used as the club's summer quarters. The club became noted for its many social events, the best known being the annual Washington Ball and the annual Field Day. In the early 1960s, a huge fire destroyed the club's quarters. The building was later replaced by a small cement-block building. The club's membership began to drop off, and the property was sold in 1996.

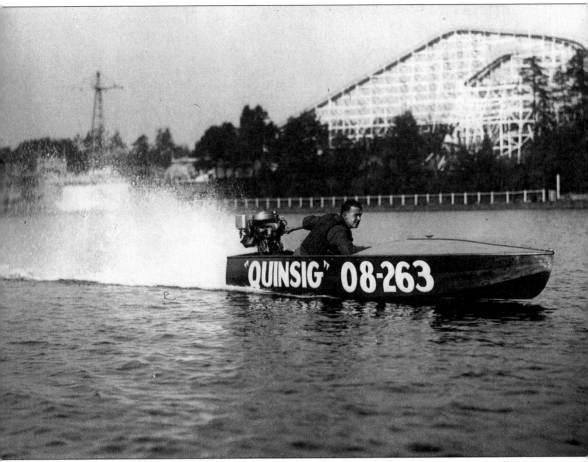

Roscoe G. Bicknell is shown driving a hydroplane outboard powered by an Evinrude 24-horsepower motor. The Bicknell Company made the boat. The photograph dates from the late 1920s. The White City Amusement Park is seen in the background, including the huge roller coaster. (Courtesy Roscoe Bicknell.)

Of all the exciting acts that appeared at the White City Amusement Park, the most spectacular was probably King and Queen, who were billed as "J.W. Gorman's diving horses." They were a pair of snow-white horses that would somehow be coaxed up onto high platforms overlooking Lake Quinsigamond. They would then amaze the crowd by diving right into the lake.

QUEEN

A popular fishing derby was run by the Lincoln Park Hotel, which stood at the southeast corner of the intersection of Route 9 and Lake Avenue in Worcester. As an 11 year old, the author got up before dawn, traveled to a prime fishing spot at the northern end of the lake, and was lucky enough to catch a 16.5 inch rainbow trout. Entered in the Lincoln Park Hotel Derby, the fish was large enough to win the Junior Division first prize, which was a great thrill for a young fisherman. The prizes consisted of an expensive fly rod and a pretty sizable trophy. The winning entry ticket, which cost 25¢, was rediscovered many years later in a desk drawer.

When the 1939 World's Fair ended, an elaborate fountain was purchased and installed at the White City Amusement Park. It is described as being 40 feet high and made of stainless steel, heavy glass, and colored lights. One account tells us, "As water fell in a cascade from the top of the fountain it reflected all the beautiful colors of the rainbow." Here we have Jesse and Bea McKee standing in front of the fountain on a summer weekend in 1947.

A popular attraction at the park was the Custer Cars. These were similar in design to a modern-day go-cart, powered by what was described as a "one lung" engine. Each rider would guide their Custer Car along a winding track. In a 1947 photograph, Bea Mckee poses on one of the Custer Cars.

Six

PEOPLE AND PLACES

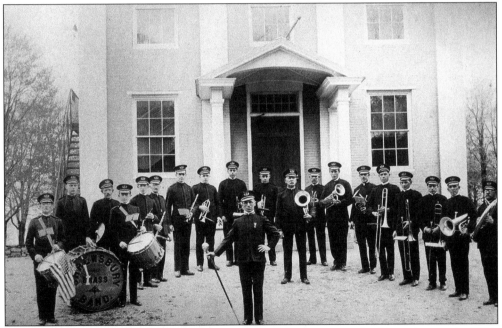

The Shrewsbury Brass Band is shown during one of the later periods of its existence in 1914. The band is arrayed in front of the 1830 Brick School on the town common. At this time, Walter Gleason was the bandmaster. He is standing at the center of the photograph holding his baton. Gleason was the town undertaker. In a vast contrast to his usual profession, however, he enjoyed appearing as a clown in many of Shrewsbury's parades and activities.

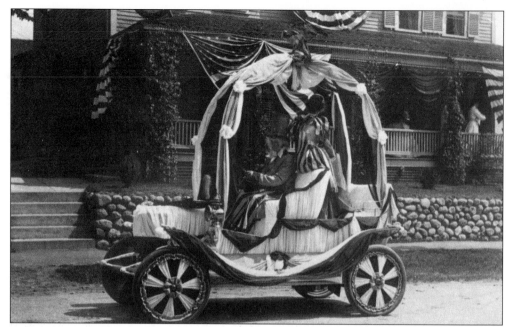

In 1907, Mr. and Mrs. Fred M. Hickey portrayed Uncle Sam and Columbia while driving their decorated automobile in Shrewsbury's Old Home Week parade. Theirs was one of only three automobiles to participate in the parade. The vehicle was decorated in red, white, and blue. The parade itself was led by Chief Marshal T. Frank Hickey riding his horse Wonder. The parade was just part of the Old Home Week activities, which several area towns observed during this era. (Courtesy Shrewsbury Historical Society.)

"Old Home" Celebration

Shrewsbury, Massachusetts

August 2, 3 & 4, 1907

"Such is the patriot's boast, where'er we roam,
His first, best country, ever is at home."—Goldsmith

To the absent Sons and Daughters of Shrewsbury, either by birth or adoption:

The Town of Shrewsbury cordially invites you to be present at this "Old Home" Celebration. Whatever measure of success has crowned your efforts in your adopted home, remember this as the OLD HOME, the home of your ancestors, and join in this celebration, thus helping to keep fresh the friendships, the memories, and the histories of other days.

By kindly acknowledging the receipt of this invitation to the secretary of the Invitation Committee at your earliest convenience, you will confer a favor on the committee. Also please inform the committee if you wish hotel accommodations.

CLARA D. WARD,
Secretary of Invitation Committee.

H. A. MAYNARD, Chairman of Town Committee.
GEO. E. STONE, Secretary of Town Committee.

As part of the Old Home Week celebration, invitations were sent to past residents of Shrewsbury. These were sent out far and wide, requesting that these same people return to their hometown for the festivities. The response was overwhelming and Old Home Week was a great success, with people attending from as far away as St. Albans and Rutland, Vermont; Providence, Rhode Island; and Saco, Maine.

In 1948, members of the town's fire and police departments founded the Shrewsbury Fire and Police Relief Association. As both a fundraiser and social event, an annual ball became a tradition that lasted almost 20 years. The balls were held at a number of locations, although the old town hall was used most frequently. Some of the more famous personalities that provided dance music included Vaughn Monroe and Tommy Dorsey. In 1956, the ball was held at the town hall. Pictured at the affair is a group of firefighters and their wives. The men are attired in their blue dress uniforms and the ladies in evening gowns. They are, from left to right, as follows: (front row) Capt. Andrew LaFlamme, Bernice LaFlamme, Helen Parsons, Chief James Parsons, Barbara Geraldi, and Pvt. Anthony Geraldi; (middle row) Pvt. Joseph Cummins, Evelyn Cummins, Enis Leroux, and Capt. Alexander Leroux; (back row) Pvt. Michael Perna Sr. and Angie Perna. The annual ball continued until 1965.

FRANKLIN W. BRIGHAM CAMP, NO. 147
S. of U. V. of the C. W.
Shrewsbury, Mass.

Meetings; 1st. and 3rd. Mondays, 8 p.m.

Dear Brother:

Our Camp Treasury is in need of YOUR ASSISTANCE!
Realizing that the matter of QUARTERLY DUES easily slips from our mind if one is not notified, we ask YOU to please forward your DUES

From _____ To _____

Total _____ To _____

CAMP NO. 147, SHREWSBURY, MASS.
Yours in F. C. L.

..Treasurer.

Shrewsbury had its own camp of the Sons of Union Veterans No. 147. It was named after Dr. Franklin Whiting Brigham, who had served in the U.S. Navy during the Civil War. Shown here is a dues reminder for the members of the camp who might have been a bit tardy in keeping their membership current. The Sons of Union Veterans No. 147 Camp in Shrewsbury slowly grew smaller after the deaths of the last Civil War veterans. As far as most people remember, the camp went out of existence sometime after World War II.

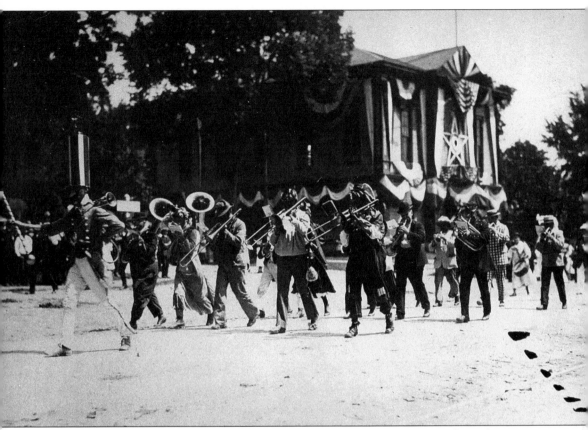

The "horribles" were a part of many Shrewsbury parades in the late 1800s. These characters poked fun at almost anyone and anything. In the Old Home Week parade of 1907, there was the Bingville Fire Brigade of West Shrewsbury, a take-off on the town's two fire companies. The Shrewsbury Brass Band had 25 horribles marching, shown here, led by drum major Lewis Gates.

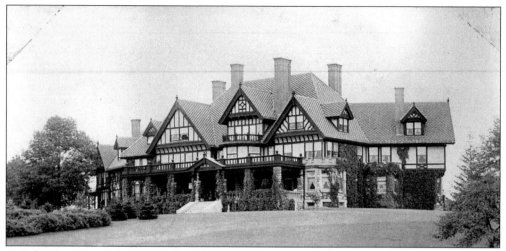

Built by the prominent industrialist Philip Washburn Moen, the mansion then known as Ard-Na-Clachan (Scottish for "house on the green") was part of one of Shewsbury's largest estates. The mansion contained 30 rooms with 17 fireplaces. The estate was purchased by Charles Hutchins in 1912 and became known as the Hutchins Mansion. Bought by Howard Brewer in the 1920s, the estate changed hands again and was then known as the Brewer Estate. The estate was sold to the Worcester Foundation for Experimental Biology in 1962. The mansion itself was torn down in the mid-1970s.

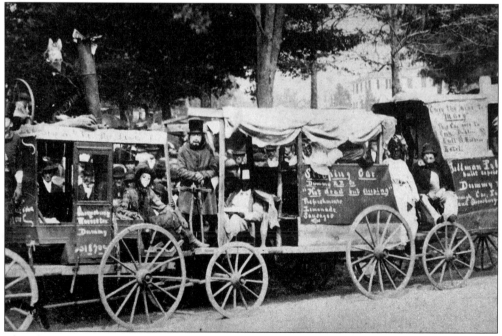

The Shrewsbury Cattle Show was a popular yearly event for many years. Prizes were awarded for the best vegetables, fruits, canned goods, and other items. Plowing competitions were held, along with parades, bands, and other activities. This photograph from the Shrewsbury Cattle Show in 1870 shows a spoof of the proposed extension of the Shrewsbury and Worcester Railroad, sometimes known as "the Dummy." Despite several attempts, the little railroad never was extended from Lake Avenue in Worcester to Shrewsbury.

Starting in the post–Civil War years, Memorial Day ceremonies were serious business in town. For many years, the Civil War veterans of E.A. Andrews Post No. 135, Grand Army of the Republic, were featured in parades and public gatherings. Graves of veterans were decorated faithfully each year. As the Civil War soldiers passed on, the Sons of Union Veterans took their place. In this 1930s photograph, part of a Memorial Day parade is passing by. The color guard members are identified as Reverend Thayer, Clarence Cook (a member of the Sons of Union Veterans), an unidentified member, and Albert Gifford.

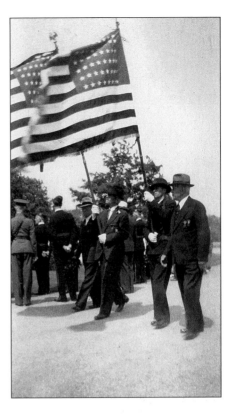

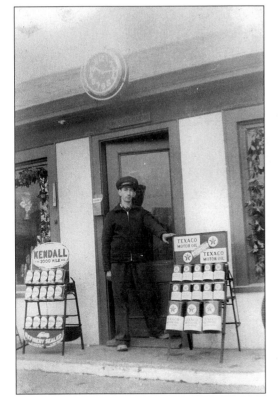

When automobiles started becoming more common, people needed a way to get fuel for them. Many people objected to gas stations being built, but eventually the increasing need overcame their objections. In this photograph, we see Donald Dufresne working at a gasoline station in the Fairlawn section of town, where a number stations were built in the 1930s.

In the 1920s, 1930s, and 1940s, Shrewsbury High School had school newspapers that went by various names such as the *Hookup*, *Gazette*, and *Colonial*. During many years, there was no paper at all. Probably the longest lasting of these was the *Sphinx*. First published in 1923, the *Sphinx* was at times a few pages long and at others almost as large as the yearbooks of those days. The *Sphinx* included sports news, essays by students, and articles about school events. During the 1920s, the *Sphinx* was a part of life for the students at Shrewsbury High School, a tradition that the school's *Town Crier* has carried on since the 1950s.

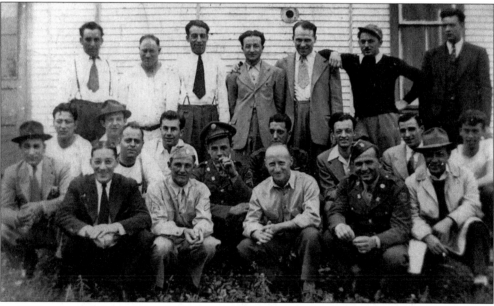

In 1937, a group of men from the Lake section of Shrewsbury formed the Lakemen's Lodge. This organization was created to secure better town services for that part of town. For many years, "lake" residents felt that the "center" people received first priority when it came to things like road improvements, schools, and sidewalks. At first, the Lakemen's Lodge met in rented quarters, but after a few years secured a portable schoolhouse from the town. This building was moved to a site near Jordan Pond, where it served until larger quarters were needed. Eventually, a building on South Quinsigamond Avenue was purchased. The organization became mostly inactive in the post–World War II years. However, on September 21, 1996, the members, now almost all in their 70s and 80s, held one last get-together to close out the affairs of the club. This group largely accomplished the purpose stated in their motto: *Commune Bonum*, or "For the Common Good." (Courtesy Margaret Mattero.)

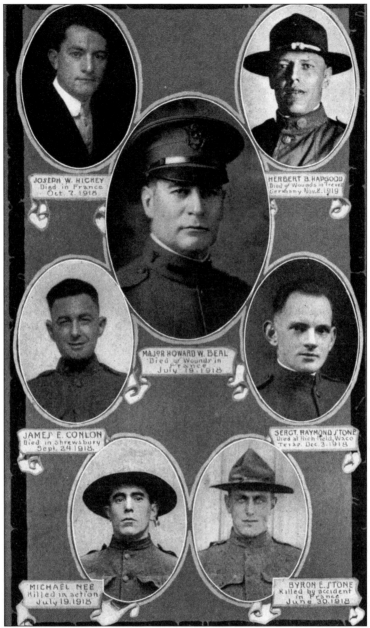

When the United States became involved in World War I, more than 100 Shrewsbury men and women answered the call to arms. Of these, 61 served overseas and seven lost their lives. The following seven men died in the service of their country during the war: Pvt. Michael J. Nee (Infantry) was killed in action in France on July 19, 1918; Pvt. Byron E. Stone (Infantry) died in France on June 30, 1918; James E. Conlon (Field Bakery Department) died in Shrewsbury on September 24, 1918; Maj. Howard W. Beal (a doctor in the Hospital Service) died in France on July 19, 1918; Sgt. Raymond Stone (Signal Corps) died at Rich Field in Waco, Texas on December 3, 1918; Joseph W. Hickey (Ordnance Department) died in France on October 7, 1918; and Pvt. Herbert B. Hapgood (Infantry) died in Germany on November 8, 1918. This collage of portraits was taken from a program for Shrewsbury Honor Day in 1919.

Shrewsbury has long been home to troops of the Boy Scouts of America. Although research has failed to reveal the date of the first troop being formed in town, we know that the scouts were active as early as World War I, when a town report makes mention of them helping in community activities supporting the war effort. Since that time, scouting has been an integral part of the town. Generations of young men have learned a great deal from their time in the Boy Scouts. In this photograph, we see scout Donald Dufresne in full uniform, including hat, neckerchief, shirt, and pants. The photograph probably dates from the late 1920s.

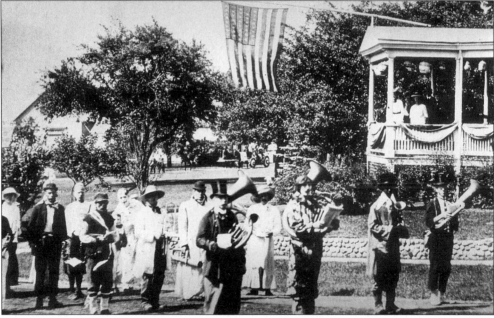

The Shrewsbury Brass Band was active roughly between 1843 and 1894. At times, the band would appear as the Studelfunk Band with outrageous costumes, as shown here. The band was hugely popular and was a fixture at any town event. They even played in towns throughout the area. In one instance, they played as far away as Rhode Island.

Hiram Conant Reed moved to Shrewsbury in 1845, when he went to work in Capt. Leander Fales shoe shop at the age of 19. He was a musician and quickly joined the Shrewsbury Brass Band. By 1847, he was chosen as the leader of the band, a post he held for 51 years. For all those years, he was a staunch supporter of the band, which performed throughout the area. Hiram Reed passed away in 1898 at the age of 73 and is buried in Mountain View Cemetery.

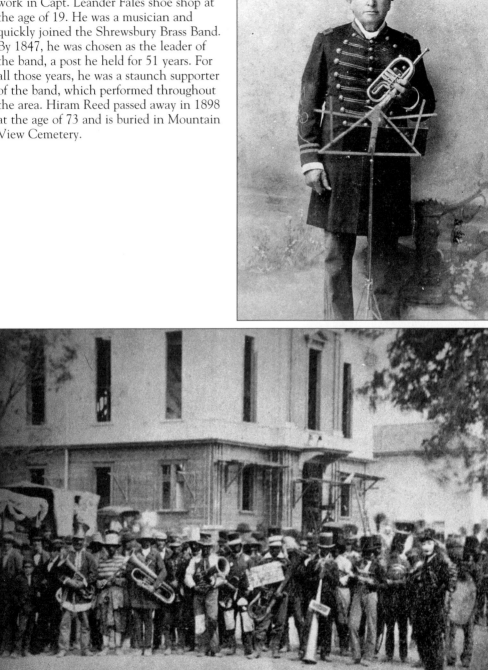

This stereopticon view was taken when the town hall was being built in 1871. The group standing in front of the building is the Studelfunk Band—really just the Shrewsbury Brass Band dressed in humorous uniforms. The Studelfunks were featured in many parades and social activities of the time.

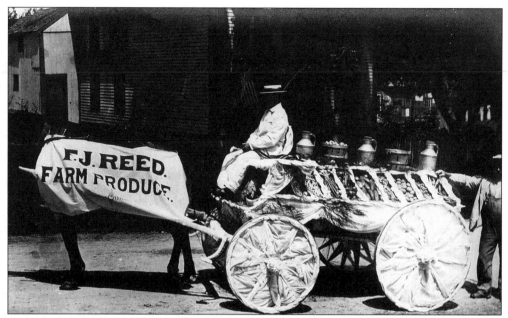

As part of the 1907 Old Home Week celebration, several local businesses entered floats or wagons in the parade on August 3, 1907. Fred J. Reed was no exception. His wagon was described in a newspaper article that covered the event: "Fred J. Reed's outfit represented vegetable gardening. The rig was decorated with pink and white and all kinds of vegetables were displayed in boxes. The driver was Edward Bruno." (Courtesy Shrewsbury Historical Society.)

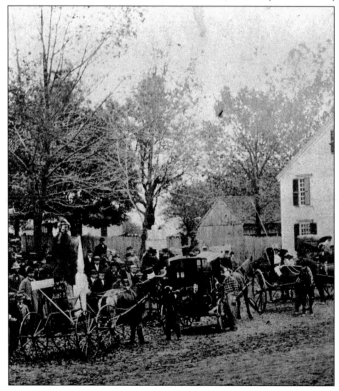

This view shows one of the town's cattle shows. In the wagon on the left, we find the Witch of Endor, portrayed by Mrs. E.T. Rand. The wagon's driver is George S. Boutell, who is dressed in an outfit resembling a Ku Klux Klan uniform. These wagons were part of a horribles parade. On the right is the Cushing-Haven Tavern. Just to the rear of the tavern is a rare view of the first Quinsigamond Engine House. This building was moved in 1871 to a spot just about where the present fire headquarters building stands today.

Fire Chief George Mullen, along with Santa, poses with their guests at a children's Christmas party in 1946. Mullen is standing on the far left. The children are standing on the department's 1927 American LaFrance ladder truck. When it was first purchased, this truck was the latest in equipment. The ladder truck stayed in service until it was replaced in the early 1960s.

Thomas S. Bates was one of several Shrewsbury men who produced postcards during the 1910–1920 era. This card shows Edgewood Farm, which was the Bates homestead on Reservoir Street, and Motion Boy, Bates's Morgan stallion. Bates rode Motion Boy in the Old Home Week parade of August 3, 1907. This fact was noted in the newspaper, thus making Motion Boy one of the very few identified horses from Shrewsbury's past.

The *Shrewsbury Guide Post* was printed each year by Ralph McKenzie, a well-known local figure who sold it door to door. Although McKenzie sold local businesses advertising space in each issue, the *Shrewsbury Guide Post* also contained bits of historical trivia, photographs of local buildings, a street directory, and important phone numbers. Notices meant to be helpful to visitors were also included, such as "If you are a stranger in Shrewsbury visit Lake Quinsigamond" or "Visit Balanced Rock opposite Rawson Hill on Boylston Street." All in all, the *Shrewsbury Guide Post* was a handy-dandy little booklet that was not quite like anything seen before or since.

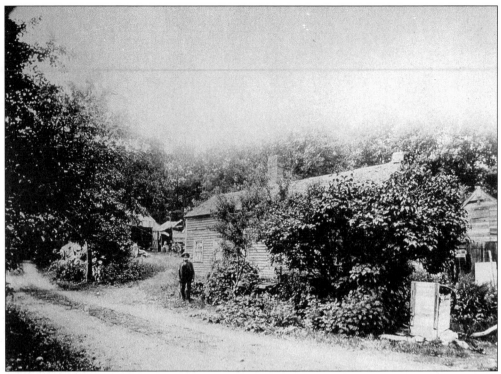

In the 1890s, a Mr. Garfield was the owner of a well-known junk business on Gulf Street. Any and all types of junk could be found at the Garfields, who made quite a nice living buying and selling this and that. Garfield is shown here, standing near what is now Gulf Street, although the wide variety of junk that covered the property is not to be seen in this view.

PROGRAMME

OF

Shrewsbury

Grange

No. 101,

Patrons of Husbandry

Jan. 1, 1895, to Jan. 1, 1896

The Shrewsbury Grange No. 101, Patrons of Husbandry, was organized on March 10, 1876. As Shrewsbury was primarily a farming community, the organization was very popular. By 1914, the Shrewsbury Grange No. 101 had a membership of 277 that included seven charter members. The group was very active—every year, 25 meetings of various sorts were held. In addition to social events and installation of officers, programs were held on farming-related subjects. These were listed in the group's program for 1914 and included Preserves and Food Stuffs, Farmer's Night, Apple Growing, and the Grange Fair.

This house at 637 Main Street was the home of Alden Cushing Stone, who served as the town clerk for 30 years. He was the fifth generation of his family to hold that particular office. Stone was a 1916 graduate of Shrewsbury High School, where he was valedictorian of his class. He was very interested in the history of Shrewsbury and wrote two detailed papers about the subject—*Shrewsbury: The First Hundred Years* and *The Second Hundred Years*. Alden Stone passed away in 1993 at the age of 94.

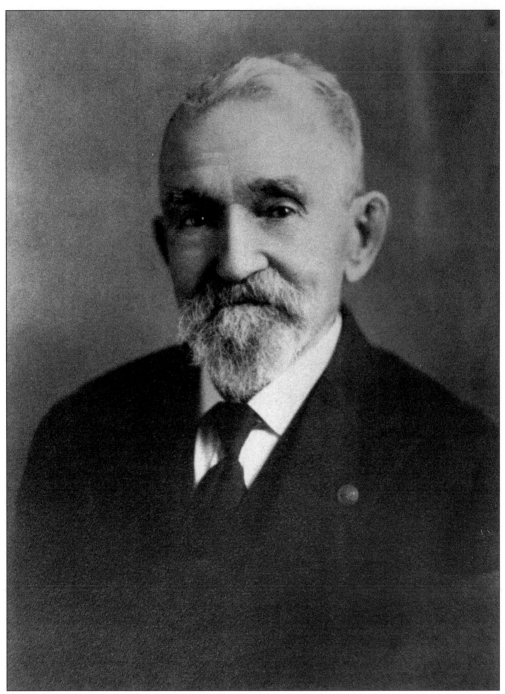

Peter Gamache was a sergeant in the 34th Regiment, Massachusetts Volunteers, during the Civil War. He was gravely wounded in the battle of Fisher's Hill but eventually recovered. Although he was living in Northborough when he enlisted in August 1862, he moved to Shrewsbury after the war. He became a member of Post No. 135, Grand Army of the Republic, and went on to be its last living member. Comrade Peter Gamache died at the age of 90 on January 10, 1929. (Courtesy Douglas Belknap.)

JOAB HAPGOOD,

GUN MANUFACTURER,

SHREWSBURY, MASS.

(A few rods west of the old Meeting-house,)

MANUFACTURES

RIFLES, FOWLING-PIECES AND MUSKETS,

OF EVERY DESCRIPTION,

MADE TO PARTICULAR ORDER AND WARRANTED.

☞Old Guns altered to go by percussion and repairing of all kinds done in good order.

March 24, 1828.

Joab Hapgood was one of the gunsmiths for which Shrewsbury was well known in the 1800s. At the age of 16, Hapgood was apprenticed to Capt. Silas Allen Jr., who was regarded as Shrewsbury's premier gunsmith at the time. He started his own business in 1826 and was known for making all types of guns and invented a way to cut grooves in rifle barrels. By 1847, his business had grown considerably, and he decided to expand it to Boston. Joab Hapgood retired from the gun-making business in 1864 and returned to Shrewsbury, where he pursued farming and traveling about the country in the winter months. He died in 1900, but the guns marked with "J. Hapgood" are his legacy.

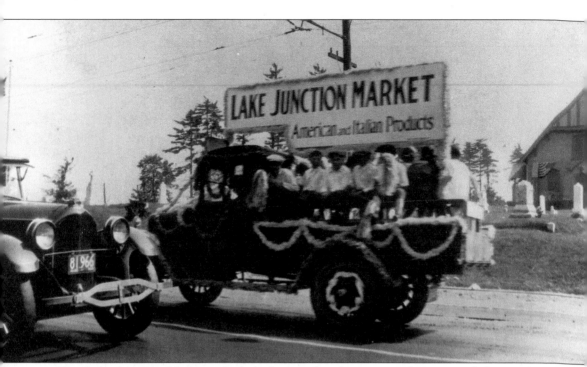

The Lake Junction Market, which had opened a few years earlier, entered this truck in the bicentennial parade of 1927. The truck, shown passing in front of St. Anne's Church on Route 9, is fittingly decorated for the occasion and carries a number of neighborhood children. (Courtesy Hugo Orrizzi.)